On Curating 2 // paradigm shifts

Interviews with Fourteen International Curators

Interviews by Carolee Thea

Nancy Adajania // Wassan Al-Khudhairi // David Elliott //
Mami Kataoka // Sunjung Kim // Koyo Kouoh //
Carol Yinghua Lu // Gerardo Mosquera //
Ugochukwu-Smooth Nzewi // Jack Persekian //
José Roca // Bisi Silva // Alia Swastika // WHW

foreword by Carolyn Christov-Bakargiev

edited by Carolee Thea and Thomas Micchelli

d·a·p

Library of Congress Cataloging-in-Publication Data is available upon request.
ISBN 978-1-938922-90-9

Editing and project management: Diana Murphy and Jordan Steingard
Design: Bethany Johns
Printing: Oceanic Graphic International, Hong Kong, China

Published by:

D.A.P./Distributed Art Publishers, Inc.
155 Sixth Avenue, 2nd floor
New York, NY 10013

Tel: 212 627 1999
Fax: 212 627 9484
www.artbook.com

Cover:
Cai Guo-Qiang, *Inopportune: Stage One*, 2004.
Nine cars and sequenced multichannel light tubes.
17th Sydney Biennale, 2010. Courtesy 17th Sydney Biennale
and Seattle Art Museum, Gift of Robert M. Arnold,
in honor of the 75th Anniversary of the Seattle Art Museum.
Photo: Ben Symons

contents

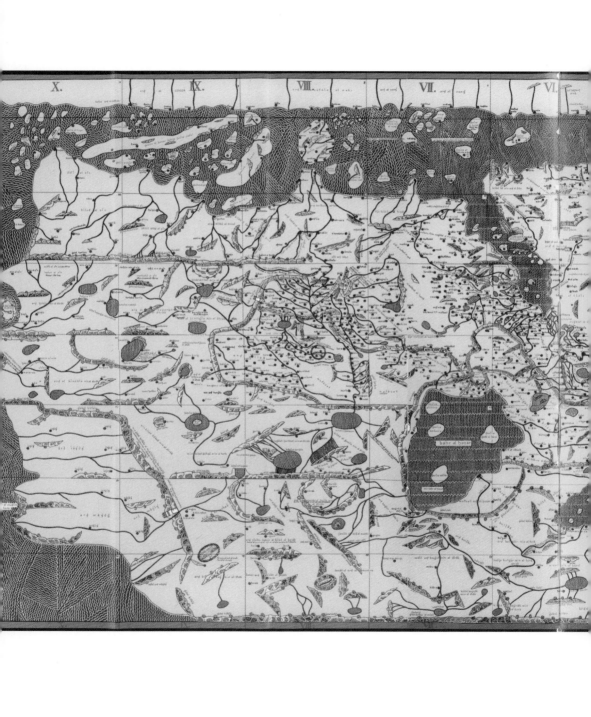

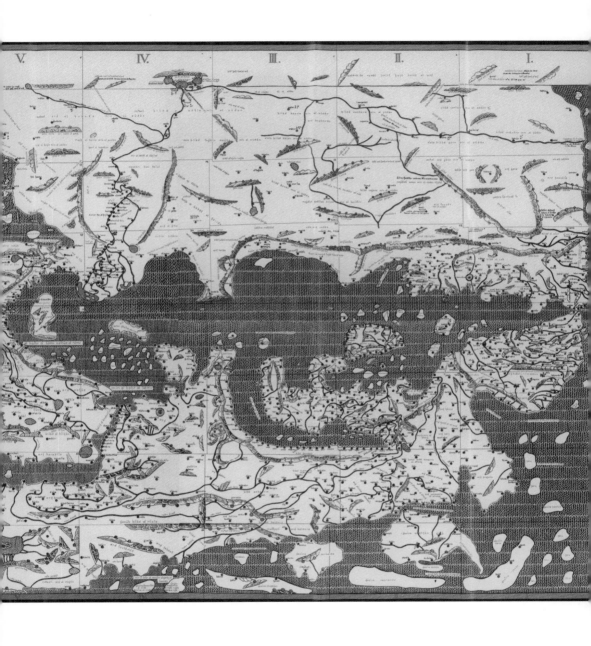

Al-Idrisi, *Tabula Rogeriana*, 1154.
Exhibited on Reading Table,
9th Gwangju Biennale, 2012

Foreword

This is a beautiful book, a polyphony of voices struggling to envision with artists a better world than most people on the planet inhabit today, amid shards of war, its rubble, environmental catastrophes, and forced diasporas. Carolee Thea thinks about this world through art, but she does so mainly via the visions of people looking at art and contemporaneity, engaging in the world through what they do with art and artists in exhibitions. In particular she is fascinated by the story, implications, motivations, and meanings of the large scale ("global," "international," "transnational," etc.) periodic shows that have characterized recent years: the biennials, triennials, and Documenta exhibitions of the late twentieth and early twenty-first centuries. This is narrated through dialogues with curators—those intelligent people, individuals or collectives, who travel the world and put these projects together with all their energy, vitality, optimism, and imagination.

In her first book of interviews with curators, called *Foci* (2001), Thea mixed the founding generation of exhibition makers (*Ausstellungsmacher*), such as Harald Szeemann and Kaspar König, with emerging curators of the time (Hans Ulrich Obrist, Hou Hanru, and Maria Hlavajova), focusing on the form and methodology of curatorial practice.

In her second book, titled *On Curating* (2009), she broadened her perspective to include an artist-organizer (Rirkrit Tiravanija), performance art (RoseLee Goldberg), the crisis of Eurocentric perspectives (Okwui Enwezor), as well as the crisis of "curating" in relation to the notion of the contemporary itself and its compromises with power and the market of art (her interview with me was included in the second book).

In this admirable and refreshing third collection of interviews with curators, Jack Persekian in Jerusalem says, "In areas that are very close to here, you see all these wars, you see all this destruction, because people are hopeless, and hopeless people, desperate people, do desperate things." This seems to be a leitmotif among all the curators of art exhibitions in the Global South and in former socialist countries today, areas that are the particular focus of Thea's present book. Whether from Asia, Latin America, Africa, or other regions, they all concur in viewing the biennial as a place of potential emancipation, often emerging from artist-run or non-governmental alternative spaces. Uninterested in the compromises with power in the Global North, they journey on to investigate, critique, and offer alternative models of living through their practice as exhibition makers.

The interviews with Gerardo Mosquera, Ugochukwu-Smooth Nzewi, Bisi Silva, Koyo Kouoh, José Roca, Jack Persekian, WHW, David Elliott, and the curators of the 9th Gwangju Biennale (2012)—Nancy Adajania, Wassan Al-Khudhairi, Mami Kataoka, Sunjung Kim, Carol Yinghua Lu, and Alia Swastika—all resonate with these questions and urgent issues.

Art can change the world, it seems. Additionally, the experience of art distracts from daily hardships and inspires people to imagine other ways of living that are less painful and more flourishing. Its experience proposes a more fulfilling life. After all, joy is an inalienable human right, and we in art believe in joy and life.

I salute this book and am honored to participate in sending it out into the world.

—Carolyn Christov-Bakargiev
 Istanbul and Chicago
 October 2015

/ <u>Carolee Thea</u>
Introduction

After 20 years of research, travel, and interviews with international curators, I can confirm that a lively system of art biennials is thriving around the world, and especially outside Europe and America. Spawned by their more formal Western predecessors and motivated by the forces of history and politics, the newer incarnations of the biennial often occur in the cities of the postcolonial world and the Global South, as well as countries that were once part of the Soviet Union. The new generation of curators who are organizing these surprisingly provocative and experimental exhibitions are the subjects of the interviews collected in this book.

The traditional Western biennial has also metamorphosed. In recent years it has become a transnational marketplace for elite consumers and an emblem of the new corporate imperialism that stems from the neoliberal economic policies, which favor the deregulation of markets and industries, the diminution of taxes and tariffs, and the privatization of government functions. The Venice Biennale of 2015 epitomizes the paradoxical nature of the mainstream twenty-first-century biennial. Titled *All the World's Futures* by its curator, Okwui Enwezor, it was a critique of capitalism and consumerism, a denunciation of the growing distance between rich and poor, and a reminder of the plight of the politically oppressed in these and other turbulent times. Live readings of Karl Marx's *Das Kapital* were contrasted with the evident partiality given to the high-end galleries that financed the participation of their artists in the show, and the presence of the mega-yachts of billionaire collectors moored in the Venice lagoon.

The most innovative and thought-provoking biennials are now to be found elsewhere. More elastic in form and more politically pointed, these exhibitions are not as heavily invested in the capitalist-driven Western art market as are the traditional biennials in the Global North. In Africa alone there is the Dak'Art Biennial, in Dakar, Senegal; Bamako Encounters: African Biennial of Photography, in Mali; the long-running International Cairo Biennial; the Marrakech Biennale, in Morocco; and, recently, Picha, the Lubumbashi Biennale, in the Democratic Republic of Congo, and the Luanda Triennale, in Angola. Today a biennial in the Global South can serve as means of mobilizing Latin American and Caribbean solidarity, promoting Afro-Asian unity, or introducing emancipatory politics that transcend longstanding antagonisms, as in post-apartheid South Africa. These are some of the examples of how the paradigm shifts have become manifest; others continually evolve.

The biennial evolution into the twenty-first century began in 1984, when Gerardo Mosquera founded the Bienal de la Habana. This exhibition became the fourth major international biennial—after Venice, São Paulo, and Sydney—and the sixth international periodic art event to be established, following the above-mentioned shows, the Carnegie International, and Documenta. Truly global, the Havana Biennial included the art of the Third World, and had a tremendous influence on the subsequent emergence of a dramatically expanded art world. Cuba set out to assert itself as a Third World cultural leader within and on behalf of the Soviet bloc. The biennial's geographic location in the Caribbean, and in the Western hemisphere, as well as its emphasis on artists from developing countries in the Southern hemisphere, made this a significant move. State-sponsored and anti-capitalist, it began in the waning days of the cold war and was emblematic of the cold-war divide that lasted from the late 1940s until 1989. This global political partition into power blocs, and into a hierarchy of more developed and less developed nations, provides the starting point for understanding the emergence of today's transnational system of biennials.

During much of the cold-war era, the First World was defined as the richer, more developed regions of North America, Western Europe, and parts of East Asia. The Second World was made up of the 19 Socialist states under the influence of the Soviet Union. The partition also gave rise to the Non-Aligned Movement, founded in 1961, which advocated a middle course for states seeking to find their own path between the Western and Eastern blocs. It included Ghana, India, Indonesia, and Yugoslavia. The Third World (in today's parlance, the Global South) encompassed the poorer, less developed regions in Africa, Latin America, and developing Asia as well as the Middle East. The fall of the Berlin Wall in 1989 and the dissolution of the Soviet Union in 1991 presented catalytic moments in the move away from the three-world partition of the cold war and toward a new world order. The old political categorizations were increasingly replaced by an economic global stratification that divided the world into developed, developing, and underdeveloped countries.

The newer incarnations of the biennial often occur in the countries of the Global South, the nations of the former Second or Third World. For them, such exhibitions are useful tools for economic and social development, encouraging the host cities to expand their artistic and cultural infrastructures. Seen as an alternative to existing cultural institutions, museums, or historic ruins, these shows can stamp a city with a new reputation as a go-to place. Biennials can also offer a country the opportunity to display its international or local cultural consciousness, and to stimulate education, architecture, tourism, and finance.

In the first quarter of the twenty-first century, historians have been searching for a new kind of internationalism, one that tracks mass movements and communications across and beyond nations, for example, the diasporic movements of our time. This kind of historical vision looks beyond the nation-state. It is interested in the things ordinary people do in spite of or even against the state. Issues such as universal human rights, gender equality, or protection of the environment all highlight the local while interweaving the global. One of the curators interviewed in this book, Ugochukwu-Smooth Nzewi, emphasized that all art is connected to local communities: "An artist in the West is no different from an artist in Lagos who engages or understands the international through the local." Another, Gerardo Mosquera, acknowledges that internationalism or globalization in art will not erase cultural individualities. He remarked in his interview here, "Many artists are using a sort of English, a sharing of certain codes and methodologies that allows us to communicate. Within that, artists are doing different things that evolve from their cultural, personal experience."

Who are the curators interviewed in this book? Gerardo Mosquera organized the first, second, and third editions of the Havana Biennial. WHW (What, How & for Whom)—a Croatian curatorial collective made up of Ivet Ćurlin, Ana Dević, Nataša Ilić, Dejan Kršić, and Sabina Sabolović— was responsible for the 11th Istanbul Biennial. Six Asian women served as the curatorial team for the 9th Gwangju Biennale: Nancy Adajania, Wassan Al-Khudhairi, Mami Kataoka, Sunjung Kim, Carol Yinghua Lu, and Alia Swastika. Ugochukwu-Smooth Nzewi co-curated Dak'Art 2014. Bisi Silva co-curated an earlier and formative edition of Dak'Art, in which her appreciation for alternative independent spaces in Africa became paramount. Koyo Kouoh worked on three Documentas and founded RAW Material Company in Dakar, Senegal, as a place where contemporary visual artists could discuss their practice in a critical and intellectual environment. David Elliott, a cultural historian and curator focusing on the visual cultures of Central and Eastern Europe, Russia, and the non-Western world, organized the 17th Biennale of Sydney in 2010. José Roca directed the 8th Bienal do Mercosul, in Brazil, and Jack Persekian is the artistic director of the first, second, and upcoming third (2016) Qalandiya International Biennial, which takes place across Palestinian cities, towns, and villages.

The collapse of the Soviet Union in 1991 marked the demise of the global Communist bloc that had extended from Eastern Europe and Berlin to Cuba. But for curators of the WHW collective, Communism remained something not to be forgotten or suppressed. "The only horizon of our political imagination is capitalism, as we now know it, which is not so great," the curators said. "It presents itself as the only natural solution to human problems, a stance that should be reconsidered." Citing Milton

Friedman and the Chicago School of Economics, they regarded the idea "that the market will regulate all the needs of human society" as "a complete illusion (just as communism was), an ideological construct."

The theme of WHW's Istanbul Biennial, *What Keeps Mankind Alive?*, refers to a song that appears in Bertolt Brecht's play *The Threepenny Opera*. Reviving Brecht was part of their attempt to think about the role of artistic endeavor under the conditions of contemporary capitalism, to examine anew the nature of today's cities bursting with immigrants looking for work, and to reevaluate our everyday practices, value systems, and modes of operation. Many of the works by the artists they selected were based on the idea of social critique. Often using "poor" materials they emphasized artistic procedures that could be carried out without any kind of institutional support, and some artists, such as Sanja Iveković, combined this aesthetic with feminist messages about the state of women in Turkey today.

One of the greatest curators of the twentieth century, Harald Szeemann, set out to systematically trace the relationship of visual forms of expression to reality. He said, "The changes you see with artists' works are the best societal seismographs. Artists like curators work on their own, grappling with their attempt to make a world in which to survive."[1]

The civil uprising in South Korea in 1980 was a result of the violent repression of the Gwangju Democratization Movement in that country. Reflection on this uprising may help to deepen our understanding

1. Carolee Thea, *Foci: Interviews with Ten International Curators* (New York: ApexArt Curatorial Program, 2001), p. 17.

of the cold-war climate that condoned repressive regimes within the U.S. orbit as long as they were sufficiently anti-Communist. The 1980 events remain an ever-present memory in Korea, and the aftereffects of the uprising provided the impetus for the launch of the 1st Gwangju Biennale, in 1995. Sunjung Kim, one of the curators of the 9th edition, held in 2012, states, "The military killed so many citizens here. I know the history and everybody in Korea knows this history. I'm from Korea. Foreign curators, though they knew of this civil uprising, did not share my more emotional approach to it."

The 9th Gwangju Biennale brought together a team of six female curators from different Asian countries. The title they chose for their biennial, *ROUNDTABLE*, reflected their response to the unusual situation in which they found themselves. How could six individuals who did not know each other prior to this encounter collaborate on a biennial? Sitting at a round table in a Chinese restaurant one day, after months of struggle to formulate their concept, one curator spontaneously suggested, "How about the idea of 'roundtable'?"—and so the curatorial vision began to crystallize. Each curator selected artists, artworks, projects, and programs that would allow for the creation of a unique condition in which dialogue could be

pursued around a number of issues. *ROUNDTABLE* explored issues of isolation, migration, and mass communication, as well as the relationship between group trauma, memory, and history. The curators presented a cornucopia of artworks that was minimally cohesive but as enlightening as art can be. Perhaps the biennial could best be seen as an experiment to determine if art can play a redemptive role for greater understanding among nations?

Mami Kataoka, the curator from Japan, explained, "This was not meant to be an exhibition with one single viewpoint. The decision to invite women from other Asian countries was a structural issue." Carol Yinghua Lu, from China, and Wassan Al-Khudhairi, originally from the Middle East, remarked that being together, despite the difficulties, opened up possibilities for learning about their colleagues, who might have been geographically close but not in curatorial approach. I asked the curators if they thought that this multi-community discourse could be seen as an embodiment of Pan-Asianism, and Nancy Adajania, from India, remarked, "The focus on China, India, or Southeast Asia today owes more to the idea of the Asian Century, and is premised on a model of economic advancement, not on their cultural dynamics. I am, therefore, suspicious of present-day notions of Pan-Asianism, which are more about opportunism than about seeking affinities. The idea that Asians will speak in one voice is a fallacy." Lu added that Pan-Asianism is "a symptom of the anxiety of self-definition among practitioners in Asia. The more connected we become through globalization, the more anxious people feel about defining their own identity. This anxiety has intensified over the past years." For Lu, this was exemplified in her call for artists to look inside themselves and their culture as source material.

Alia Swastika, from Indonesia, discussed the political aspect of artworks in her country: "We don't have an infrastructure to disseminate knowledge of contemporary art history, so everything is really do-it-yourself in terms of art and the cultural sector. Artists in Indonesia are always acting as activists in this sense. In fact, you cannot be just an artist."

Adajania unveiled a surprise at the entrance to her show in Gwangju, one that is especially relevant to this book. She presented a photograph of a South-oriented map by the twelfth-century Andalusian geographer Al-Idrisi, who was commissioned by Roger II, the Norman king of Sicily, to produce a comprehensive map of the world and the largest atlas to date. Al-Idrisi's map introduced a completely different way of imagining the known world. It continued Pharaonic Egypt's south-oriented geography and cosmology, and also emphasized the importance of the African and Indian Oceans in the context of Mediterranean trade, culture, and power. Expanding on this geographic notion, Adajania talked about "the Silk Route and its adjunct cultures as 'globalism before globalization,' [where] goods, arts, ideas, and narratives came together. These were stages for cultural

encounter and experimentation, with far-reaching consequences for Buddhism, Christianity, Hinduism, and eventually Islam, as well as the societies in which these religions flourished." Al-Idrisi's southerly oriented map provides a startling context to an exhibition devoted to the Global South, as well as an icon for aesthetic and political evolution.

I interviewed David Elliott in 2011 about his views on interdisciplinary exhibitions as vehicles for social change—a concept that reflects his perception that the European/U.S. power nexus is over: "Today we're entering another world in which power is distributed differently. I am not implying that the West is finished but it's no longer calling the shots and can no longer claim the moral high ground in the shameless way it tried to do before."

As artistic director for the 17th Biennale of Sydney, THE BEAUTY OF DISTANCE: Songs of Survival in a Precarious Age (2010), Elliott was concerned with both aesthetic and critical distance to reflect "on the history of [Sydney] in particular and colonization in general, and on definitions of contemporary art, especially in relation to such 'excluded' practices as the art of First Peoples and folk art."

One of Elliott's more arresting selections for the exhibition was presented at the Museum of Contemporary Art, the Biennial's largest exhibition space. He describes the objects on display as "110 vertical larrakitj, or memorial poles, which were made between 1998 and 2009 by 41 Yolngu Aboriginal artists from northeast Arnhem Land, in Australia." Larrakitj were not originally considered art; rather, in precolonial times they had a funerary function, to store the bones of the deceased. After colonization and conversion to Christianity, the ritualistic aspect faded and they are now made solely for aesthetic reasons.

In contrast, Cai Guo-Qiang's Inopportune: Stage One (2004), another major work shown in Sydney, illustrates the dangerous age in which we live, representing both an aesthetic and political position. Made up of nine cars with a syncopated system of LED tubes radiating off of them, it evokes "a car crash or a huge explosion," Elliott says. "In its grisly beauty the work refers to terrorism and the precarious age in which we live, a theme that ran through this exhibition in many different ways. Cai wrote about his fascination with the incandescent beauty of the terrorist act as well as his incomprehension about why someone should sacrifice their own life for such a cause."

In another timely piece, Fiona Hall, a contemporary artist from Australia, created The Barbarians at the Gate (2010), an installation revolving around ecology, paranoia, and racism. Comprised of functioning beehives painted in military camouflage, whose tops were carved into the shapes of iconic buildings from around the world, the work was originally meant to host foreign bees, which, unlike native Australian bees, have the ability to sting, but customs officials prevented the artist from using them.

Elliott calls *The Barbarians at the Gate* "an elegant and sardonic work that reflected the insecurities of foreign policy and social divisions within Australia as well as those much farther afield." Today it can be seen as alluding to a range of issues, from the sprawl of botanic traffic around the world to Europe's treatment of millions of displaced migrants and refugees from the Middle East.

The Mercosul Biennial, which was founded in 1996 in Porto Alegre, Brazil, follows the transformative direction set by the Havana Biennial by basing the entire program of exhibitions, conferences, and workshops on a general theme while avoiding the selection of artists by national representations, and adopting a decentralized structure of multiple events that link with the whole region. Taking the theme Essays on Geopolitics for the 8th edition, in 2011, Colombian curator José Roca invited international artists to work in regionally specific environments as a way of demonstrating alternatives to the conventional idea of nation, to suggest new cartographies and geopolitical relationships, and to reposition our understanding of the relationship between the regional and the global. The Mercosul Biennial is distinctive for its emphasis on education, broadly understood. Its policy is to choose a pedagogical curator to work with the chief curator. In 2011 the artist Pablo Helguera held this post.

The founding of Dak'Art grew out of Senegal's policy of cultural diplomacy. In 1966 the first president of Senegal, Leopold Sedar Senghor, staged the spectacular World Festival of Black Arts (Festival Mondial des Arts Nègres) in Dakar. He brought together poets, artists, writers, performers, and musicians from all over the black world, from Nigeria to Brazil to the United States. Staged in the immediacy of post-independence and reflecting the Black Power era of the 1960s, it was a unique, invigorating, and consciousness-raising event. Evolving from this precedent, the first Dak'Art Biennial opened in 1989, and in 1996 it became an exhibition specifically devoted to contemporary African art.

The 11th edition of Dak'Art, *Producing the Common*, was co-curated by Elise Atangana, Abdelkader Damani, and (interviewed for this book) Ugochukwu-Smooth Nzewi. The three curators were interested in the relationship between politics and aesthetics, and drew on Jacques Rancière's theory of "the common." Also important to their thinking was Michael Hardt's reexamination of Rancière's articulation against the backdrop of neoliberalism in the contemporary art world, and art biennials as vehicles of cultural globalization. Indeed, the contemporary biennial often seeks to maintain a neutral, museumlike authority while accommodating itself to its host city's plans for urban renewal, expansion, or international visibility.

Each curator of Dak'Art's 2014 edition was given a geographic arena from which to select artists: north of the Sahara, south of the Sahara, and the diaspora. The exhibition attempted to discuss globalization through the

framework of African-inspired ideas of communalism—what the inhabitants of southern Africa call *ubuntu.* The underlying philosophy is that one is human because of one's neighbors. The central exhibition at Dak'Art's Biennial Village was held in former television studios in an industrial area north of Dakar's city center. This venue was made available to the curators and artists only four days before the scheduled opening date. The biennial included symposiums as well as a multitude of offsite exhibitions, some a distance away and including artists not chosen by the curators. Essential to the visit, and a short ferry ride away, was the infamous Gorée Island, where children play on the streets among the historic holding cells once built for the slave trade. This site suggested a darker version of history than those conjured by the antique palaces in Istanbul or Venice.

It's important to note that there is a paucity of museums for contemporary art in newly liberated, developing nations. The absence of such has resulted in the founding of independent artist- or curator-run spaces that are distinct from most Western paradigms. In some instances, these have led to the formation of a biennial.

Bisi Silva is the artistic director of an independent art space she founded, the Centre for Contemporary Art in Lagos, Nigeria (CCA, Lagos). The organization promotes research and exhibitions related to contemporary art in Africa and abroad. It opened in December 2007, one year after Silva's stint as the co-curator for the 7th Dak'Art Biennial, in 2006.

Included in the significant programming Silva initiated at CCA, Lagos, was the exhibition *Like a Virgin*, which presented the work of two young African artists, Lucy Azubuike from Nigeria and Zanele Muholi from South Africa, who deal with the body and sexuality.

Silva's position as co-curator of the 7th Dak'Art Biennial informed her perspective and approach to supporting contemporary art in Africa. The show provided her with a large travel budget, which she used to journey through Cameroon, Ghana, and Nigeria. "Moving across West Africa got me closer to understanding the conditions in which the artists work, their support systems, and the critical discourse within in each country." For her this trip raised questions: "What are the historical, political, and social conditions that actually impact the work the artists are making? What are the difficulties they encounter?"

In 2009 Silva was on the curatorial team with Gabriela Salgado and Syrago Tsiara for the 2nd Thessaloniki Biennale. Titled *Praxis: Art in Times of Uncertainty*, the exhibition claimed to be responsive to the collapse of colonialism and the Soviet bloc, and the presumed failure of Modernism.

According to the German art historian Hans Belting, "Beyond the West, contemporary art has a very different meaning that is slowly also seeping into the Western art scene. There, it is hailed as a liberation from modernism's heritage and is identified with local art currents of recent origin. In

such terms, it offers revolt against both art history, with its Western-based meaning, and against ethnic traditions, which seem like prisons for local culture in a global world."[2]

2. Hans Belting, "Contemporary Art and the Museum in the Global Age," lecture delivered at "L'Idea del Museo: Identità, Ruoli, Prospettive," conference held Dec. 13–15, 2006, http://www.forumpermanente.org/en/journal/articles/contemporary-art-and-the-museum-in-the-global-age-1, accessed Sept. 20, 2015.

Art museums evolved from collections amassed by potentates or colonialists. For example, the Royal Museum for Central Africa, or RMCA (colloquially known as the Africa Museum), in Tervuren, Belgium, outside of Brussels, originally opened as part of the 1897 World Exhibition to display the ethnographic and natural history collection assembled by King Leopold II from the so-called Congo Free State, which was more akin to a slave state. The Congo Free State was dissolved in 1908 but the Congo itself didn't gain independence until much later.

In 2009 the architect David Adjaye was asked by the Palais des Beaux-Arts in Brussels to work on an exhibition, to be held at the RMCA, celebrating 50 years of independence for 17 African countries. Adjaye invited curator Koyo Kouoh to join him, and for Kouoh this was a life-changing experience: "To make this celebration *inside* one of the harshest of the colonialist countries was exhilarating but at the same time quite puzzling as to how to celebrate five decades of independence in Brussels."

In this exhibition, traditional art entered into a dialogue with the contemporary, thus offering an overview of the enormous wealth and diversity of the visual arts on the continent. But instead of choosing singular contemporary artists to participate, Kouoh invited six independent art spaces in Africa to present individual shows, including her own curatorial space in Dakar, the RAW Material Company.

The unique situation in Israel regarding the West Bank partition was incentive for Jack Persekian to initiate the first Qalandiya International Biennial in the West Bank. Persekian, the artistic director of all three of the Biennial's editions, created a consortium of 13 partner institutions that came together as the Foundation of the Biennial. The informal title of the first edition, *Let's Work Together,* was almost like a mantra, a mobilization phrase for all the parties involved. Persekian created the network, connecting people who otherwise might not come together due to the difficulty of mobility in this country. Each institution decided for itself what to do and how to deal with the topic. Some addressed their local history, others the history of the country, and still others imagined possible futures. They considered how to digitize the exhibition, and how to make it more widely available and accessible.

Persekian says this biennial is a form of empowerment rather than resistance. It is not about being against something or somebody. Rather, it's a call for action, for people to do things: to think, to produce, to engage, to connect and communicate, to move from one place to another,

to attract the world's attention. And more than that, Persekian wants to change perceptions of Palestine: "By introducing a kind of young, contemporary image," he explained, "we hope to gradually replace the one that is disseminated by the media—of conflict, of the war zone."

In every biennial there hovers a feeling that the event will contribute something positive to the human spirit, or even make the world better. Skeptics might regard this attitude as one of utopianism or political expediency, but Persekian clearly sees art as a liberating force:

> The problem is that here in Palestine, many people, primarily young people, do not get a chance to experience the kind of freedom art brings to people, and the kind of empowerment it provides them, or at least makes available to them. They're limited by tradition, by religion, by poor educational systems, by deprived environments that have really not much to offer, and hence, you get a nation that is in essence lacking the imagination and the opportunity to change things, and that's where I feel we've lost the battle. That's why in areas that are very close to here, you see all these wars, you see all this destruction, because people are hopeless, and hopeless people, desperate people, do desperate things.

Propelled by the increasing number of large-scale exhibitions in the world—as well as the cultural laboratories that analyze society's emotional and aesthetic changes in response to recent political, economic, and social mutations—the interest in art-making and in visual literacy is expanding. The autonomy of artists is deepening, which allows for their participation in shaping the cultural and political contours of their nations.

Artists and communities are rapidly sharing information, mingling cultures, and reinventing themselves through engagement with the cross-cultural commonalities of everyday life. The growth of digital communication has surely accelerated this movement, but finally it is the artists and curators who poetically engineer and inspire new cultural understanding and progressive thoughts.

My three volumes of interviews with international curators document an art world and its surrounding political climate in a state of continual expansion and diversification. This trajectory necessitates ongoing reportage by those artists, art historians, and cultural commentators who traverse the world on a mission, recording and revealing the times through the lens of art. To those who endeavor along those paths yet to be discovered, I wish you all a rich and rewarding journey.

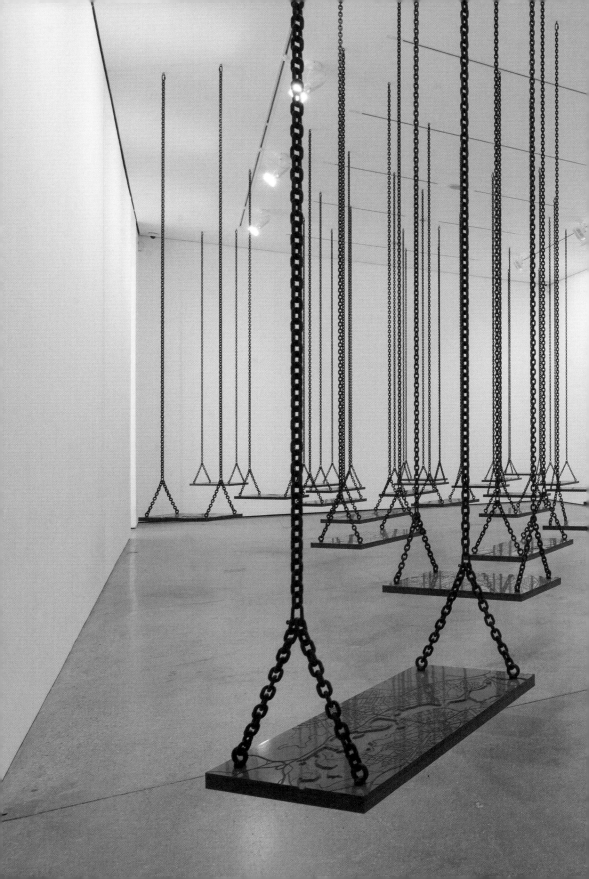

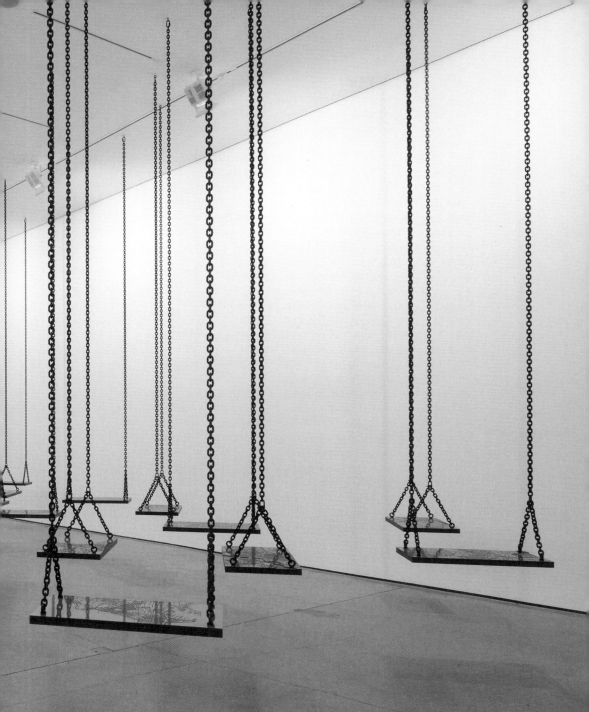

/ Gerardo Mosquera
Interview 2014

Carolee Thea: You were on the curatorial team for the first three Havana Biennials: 1984, 1986, and 1989. With its inclusion of the non-aligned countries, the Havana Biennial has had a tremendous influence on the global art world.

Gerardo Mosquera: The first Bienal de la Habana, launched in 1984, was limited to Latin American artists; it was a test and it was successful. It achieved our aim, which was to prepare ourselves for the second installment, a Third World biennial.

Bruce Altshuler remarked that the second Havana Biennial was the biggest contemporary art show ever.[1] In fact, occurring three years before *Magiciens de la terre*, it was the first global show.[2] Contrary to *Magiciens de la terre*, we focused on contemporary art, not on traditional art, and for this reason we were criticized by some radical, left wing people in Cuba and elsewhere. They said that the true art in Africa and Asia was traditional art—while, according to this interpretation, contemporary art was a colonial imposition or acquisition.

1. Bruce Altshuler, *Biennials and Beyond: Exhibitions that Made Art History: 1962–2002* (London and New York: Phaidon, 2013).
2. *Magiciens de la terre,* May 18–August 14, 1989. Centre Georges Pompidou and the Grande Halle at the Parc de la Villette, Paris, France. Curated by Jean-Hubert Martin.

CT: What do you mean by contemporary art being a "colonial acquisition"?

GM: They said that before colonization, contemporary art didn't exist. What did exist was traditional art: ritual art and religious art. Of course, we were completely opposed to that point of view. There was and is a strong contemporary art practice in these countries, and no matter if it was a result of the colonial process, it's there! Furthermore, artists who were working in contemporary ways were segregated. They were producing art that was not mimetic of the colonial impositions. They were instead using tools or images in their own way and for their own agendas.

CT: Tell me how, in Communist Cuba, an exhibition like a biennial came about? How did the reigning powers allow these poetics to emerge into a world-class show like a biennial?

GM: It was very intelligent and manipulative: by giving much needed opportunities and space to non-mainstream art, they were at the same time looking to keep control. Cuba was in fact being set up as a Third World cultural leader within and for the Soviet Bloc.

CT: Cuba's geographic location in the Caribbean, within the Western Hemisphere, made that a significant ploy.

GM: And the country's traditions played a big role as well. We were not European or African, but instead a very powerful Caribbean country with a modern, charismatic culture since the early twentieth century. Cuba was being groomed and used as an agent for Third World culture. (And in this respect we were in competition with the Chinese, who were also trying to play the role of a Third World cultural leader.)

/ **Gerardo Mosquera**

(pages 18–19)
Mona Hatoum, *Suspended*, 2011. Laminated HDF and steel. 2nd Havana Biennial, 1986. © Mona Hatoum. Photo: Hugo Glendinning, courtesy White Cube

But you see, at this time Cuba already had an influential literary contest for writers in Spanish and Portuguese Latin America, the Casa de las Américas Prize (later the prize was extended to include the English- and French-speaking Caribbean); it also organizes significant theater and film festivals. A biennial exhibition was a very important addition. Furthermore, there was nothing in Cuba in the visual arts on that large a scale. And this was Fidel Castro's idea.

 CT: That's a surprise; often art has been employed as a vehicle of political dissent.

GM: Yes, and Castro acknowledged the possibility for that, and at the same time the curators of the Havana Biennial were permitted to work freely. The government was also aware that it was impossible to organize such a big gathering, involving such a diverse variety of agents, under rigid Soviet or dogmatic Marxist frameworks.

/ Gerardo Mosquera

Ana Mendieta, *Untitled (Glass on Body Imprints)–Face*, 1972. Black and white photograph. © The Estate of Ana Mendieta Collection, LLC; courtesy Galerie Lelong, New York

It was very interesting because on the one hand the Biennial was launched by the Cuban regime for political purposes, and on the other it touched a nerve: there was the need for artists, both mainstream and peripheral from all over the world, to have a place to meet, to launch their work, and to make themselves visible. Havana is well located for that!

CT: Would you say that, in a certain sense, this Biennial was like a global Salon des Refusés?

GM: Yes! I have used that term because it created a new space beyond any political commitment. This satisfied an international need! We were able to work freely, and my ideas were quite influential in support of contemporary art from diverse countries. Furthermore, from a marginal situation, these artists were appropriating the tools of contemporary art, which were taken from imposed colonial cultures, and reusing them for their own agendas.

CT: That global reach didn't happen until the second Biennial; the first one exhibited artists from only Latin America. The second Biennial, which took place in 1986, changed everything.

GM: Yes. Because it gathered artists from dozens of countries from all around the world—I would say that there were 2,000 works of art—for the first time in history. You were able to see contemporary art from the Philippines together with art from the Congo, from Korea, from Latin America.

CT: Regions previously called "Third World." What phrase would you employ today?

GM: Well, I think there is no one phrase. "Peripheries," perhaps... all these terms are very problematic—but we have to continue using them as instruments for discussion.
We also included artists from the Third World diasporas, those living in the First World. For instance, Mona Hatoum, a Brit who originally came from Lebanon, was part of the second Havana Biennial. There were artists from the U.S. as well—Latino, Latina, Asian Americans, and others—who were diasporic.
When we began our work on the Biennial, we did some research about how many artists who were neither North American nor Western European had participated in the big, international biennials—Documenta, the Carnegie International, Venice, and São Paulo. We learned that until then, throughout biennial history, only 5 percent of the artists included were non-Western. Contemporary art production that was taking place in the rest of the world was ignored. It was a critical situation of segregation! All this art was condemned to remain local.

CT: Maybe the term "Global South" describes those who have been left out but are now part of the discussion of politics, economics, and of course biennials.3

GM: It is also about the postcolonial world.

3. See the introduction for a discussion of the term "Global South." Since the 1980s journals such as *Third Text* have discussed art in this part of the world. *Third Text* challenges the boundaries of the visual arts in the confines of the Western academy, featuring leading critics alongside new voices and advanced scholarship, interspersed with radical interdisciplinary work that goes beyond the confines of Eurocentricity.

/ Gerardo Mosquera

CT: No one term seems to work.

GM: Yes. "Postcolonial" is problematic because there are countries like Ethiopia or Thailand that had never been colonized. It has become clear that the 1986 Havana Biennial initiated the term "International Globalism," and not *Magiciens de la terre*, which was advertised as the first global show. Havana triggered a new breed of contemporary biennials born of a global context.[4]

CT: Since 1984, as a leader of the curatorial work for the three groundbreaking Biennials in Havana, you have been instrumental in reformulating the premise and methodology of the event according to your own aesthetic and intellectual interests.

However, you resigned immediately after the third Biennial. Why?

GM: I was dissatisfied because although the Biennial itself advanced many things, it wasn't avant-garde enough. I wanted it to be more radical! For instance, part of my struggle was to eliminate the awards, and I succeeded. From the third Biennial on, there have been no more awards.

4. Rafal Niemojewski, "Venice or Havana: A Polemic on the Genesis of the Contemporary Biennial," in Elena Filipovic et al., eds., *The Biennial Reader* (Bergen, Norway: Bergen Kunsthall, 2010).

/ Gerardo Mosquera

Glexis Novoa, *Minefield*, 2011. Graphite on marble. Courtesy Jacqueline Shor Collection, São Paulo

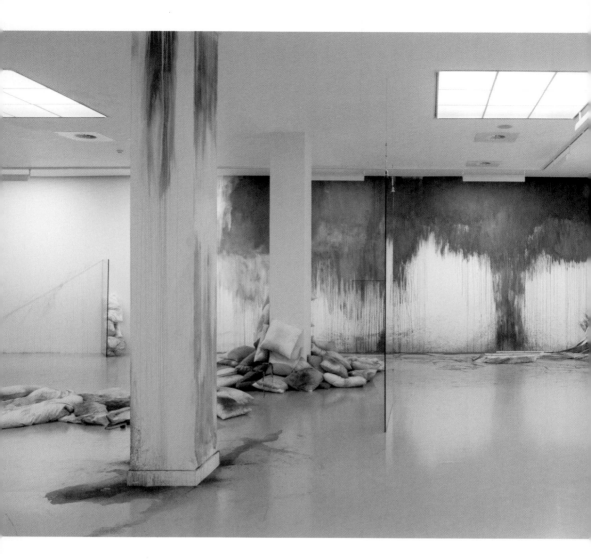

<u>CT</u>: Why was this important to you? I understood that one of the changes needed for postcolonial structures to emerge was the idea of growing institutions within these countries by giving awards.

<u>GM</u>: A biennial is not a sports competition. The awards are very problematic because art is not something you should measure like in sports, where the player who arrives first to the line wins. It is very clear to me that awards create a sense of competition, which is not healthy for a cultural entity.

/ <u>Gerardo Mosquera</u>

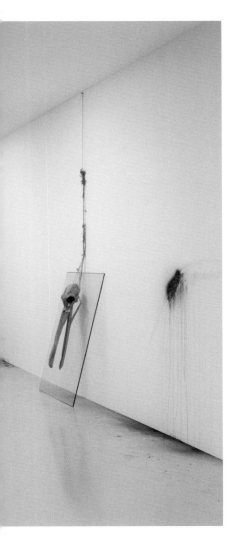

CT: Were the awards the reason you left?
GM: No. I organized international symposia for the three first Biennials; it was a pioneering experience for biennials in general: to create a theoretical meeting place where scholars, curators, critics, artists, and students would discuss issues. We published books afterward. Our Biennial was quite radical and advanced, but for me it was not enough. I wanted more drastic changes, like to eliminate the central, blockbuster exhibition. I wanted the Havana Biennial to be a true constellation of different exhibitions and programs, with no hierarchy. I wanted to further develop international workshops and to send the Biennial abroad, having venues in other countries, and to establish more dynamic communication with the audiences. I wanted to create something more decentralized.

CT: At Documenta X (1997), XI (2002), and XIII (2012), there were seminars and a 100-day exhibition, along with other activities in Kassel, Germany. And under the auspices of Documenta XIII, in Kabul, Afghanistan, with the help of curator Leeza Ahmady, a related series of seminars and a 30-day exhibition took place.

GM: They did that but they kept the blockbuster show.... Well, that in the end was remarkable, and more than welcome, but the big spectacle I was against was kept.

The Havana Biennial itself had good momentum because it coincided with a new generation of Cuban artists who renewed the art scene and beyond. I backed them and their work as well as their criticism of the regime's dogmaticians. Although tolerated to a certain extent, their criticism went beyond what the government was willing to accept and a repressive backlash against the arts ensued in 1989: censorship arose, shows were closed, and things like that.

It was my committed position to support these artists, and being part of the Biennial, which was an official institution, was no longer tenable.

Ricardo Brey, *Untitled*, 1992–2015. Sheets of glass, ventilator, chicken legs, cloth, duvet, pillows, Venetian blinds, carved wood, rope, wall drawing with pigment. *Fuel to the Fire*, Museum of Contemporary Art, Antwerp, 2015. Collection Museum of Contemporary Art, Antwerp; courtesy Ricardo Brey and Galerie Nathalie Obadia, Paris/Brussels. Photo: We Document Art, Antwerp

/ **Gerardo Mosquera**

So I decided to resign my role in the Biennial and become an independent curator.

CT: Who among those artists was prominent or important to you at that time, and whose works were controversial?

GM: I was supporting the New Cuban Artists, who were critical of the regime and bringing fresh ideas to the art scene on the island. Rachel Weiss discusses this in her recent book, *To and from Utopia in the New Cuban Art.*5 Among these artists were Tania Bruguera, Carlos Garaicoa, Glexis Novoa, Lázaro Saavedra. Ana Mendieta was also part of that process, visiting Cuba frequently.

5. Rafal Niemojewski, "Venice or Havana: A Polemic on the Genesis of the Contemporary Bienial," in Elena Filipovic et al., eds., *The Biennial Reader* (Bergen, Norway: Bergen Kunsthall, 2010).

CT: I have just returned from Dak'Art, the 11th Biennial of Contemporary African Art, in Dakar, Senegal, where I interviewed a few curators.

We discussed the influence of tribal African art and ritual practices on the contemporary, and whether or not any of these aspects are incorporated in contemporary artworks.

Did the practice of Santería—which, as a syncretic religion, combines elements of Catholicism and Yoruba beliefs—influence some of the Cuban artists of this century? Artists such as José Bedia and Ricardo Brey were involved with Santería rituals, which also appear in some of the most accomplished installations by the 1980s generation of artists.

GM: Santería has not generally influenced Cuban art so much but it did influence certain artists. Cuban art has taken a more conceptual approach to ideas, linguistic issues, and political criticism. But in the cases of Bedia, Brey, and Juan Francisco Elso (and peripherally in Mendieta's case), their art did evolve out of Afrocuban practices. They didn't use Santería representations in their work—they were not reproducing images of the gods and goddesses. No, no. What they did was to incorporate some of Santería's methodologies within contemporary, postconceptual art practice. They mixed the religion with current Western artistic practice.

CT: Was Mendieta a practitioner?

GM: Not really, even though she had participated in certain Santería rituals as an outsider. What was crucial is that, under an Afrocuban cultural influence, her art was actually a personal ritual, and less like an artistic performance in the sense of representing something within aesthetic norms. For her it was that, yes, but at the same time it was a *real* personal ritual in which she believed, and this is something that hasn't been recognized about her art.

CT: The New Cuban Artists emerged in Cuba in the early 1980s. Can you tell me more about them?

GM: They emerged during a time of increasing Sovietization of Cuban culture. *Volumen Uno* was the landmark show in Havana in 1981 that launched

this movement. It was organized by some of the new artists who came to the forefront. But this has nothing to do with the Havana Biennial. As I explained, the Biennial was benefited by a dynamic, fresh, and reinvigorating art scene that was happening in Cuba at that time.

Since I resigned from the Havana Biennial I've been working internationally. Something very important to me is the attempt to make the art world truly international, and as a curator I always try to forget about nationalities and look into the art. We are living in global times, and we curators have to work with artists from everywhere, something that I have always done: I never limited my view to Latin America or the Caribbean. Right now I am quite attracted by what's going on in Asia—it's fresh, it's powerful, with a new energy. To work with these artists, and the curators as well, is very important. I recently worked with Hou Hanru, Huang Du, and Fumio Nanjo on *PHotoEspaña*, a festival in Madrid of which I was artistic director for three years.

 <u>CT</u>: Is there is a fear that internationalism or globalization in art will erase cultural individualities?

<u>GM</u>: I think this is a misunderstanding; many artists are using a sort of English, a sharing of certain codes and methodologies that allows us to communicate. Within that, artists are doing different things that evolve from their cultural, personal experience. This English of art is spoken with strong accents, and it is in this accent where new meaning is added or created. It is a process of incorporating cultural differences and multiple experiences and histories—of combining diverse contexts, we could say—within a lingua franca we can understand, and which is transformed in the process.

These people are not creating masks or engaging in esoteric rituals. They are contemporary artists using video, installations, digital technology… But look at the ways in which they are doing this: their identity is no longer related to representation, yet it is expressed through action, by the particular way in which they create their artworks. For example, Brazilian artists are representing neither Candomblé nor Samba, but you can feel a distinct character in their art. They make installation art, for instance, with a very special sensitivity to materials, to space, to the dynamics of the way that they conceive and construct the installation. Even if the work is abstract, the cultural element is present.

 <u>CT</u>: That's a good point. Even if it's taken out of the context of its country of origin, an installation from São Paulo exhibited in Gwangju will maintain the same sensibility.

<u>GM</u>: Yes. There's also no need of full translation because they're using the international language of installation art. And at the same time it might not be possible to grasp the full meaning. However, there is a third space in which communication is achieved due to shared international codes and

/ Gerardo Mosquera

experiences. It's like the space created where two circles or spheres over-
lap. This is the third space where Korean audiences will be able to decode
the Brazilian's installation.

I think that the international is increasingly being built from a variety of
active subjects from different contexts. So, for me, the bipolarity of inter-
national/local is no longer useful. Let's say that in those segregated days
before the Havana Biennial, when only a minuscule percentage of non-
Western artists were participating in the big shows, contemporary art was
traced by what we could designate here as a straight line—I mean, in a
very schematic way: New York, London, Germany, for instance. A meta-
language of contemporary art was used along this hegemonic line. What
happened with globalization was not the interaction of cultural differences
as distinct elements within a global framework, for which you needed
some kind of translation, but an active reconstruction of the established
meta-language.

> CT: So you're saying that the straight line is now a broken one because
> of the participation of a plurality of very active agents from the four
> corners of the world.

GM: Yes.

> CT: For a brief time, the term "glocal" was viewed as politically
> correct.

GM: I'm not so comfortable with that term because it erases the contradic-
tions involved in the relations between the global and the local. Yet what
is interesting is that the new participation of these diverse cultural agents
is transforming the meta-language of art without breaking it. I mean, they
are breaking it in a way, but at the same time keeping it.

> CT: You have to fracture something in order to bring it together again,
> and this back and forth is continuous.

GM: Exactly.

> CT: For this book I'm concentrating on mega-exhibitions in the Global
> South, which includes Asia and Africa, the Caribbean and South
> America, and the Middle East.

GM: And New York!

> CT: But you know, what is often forgotten in this category of globalism
> or diaspora is New York City's Whitney Biennial of 1994, curated by
> Elisabeth Sussman.

GM: I remember that exhibition—it was a landmark.
 CT: Yes, it was reviled in the press because there was a lack of under-
standing about the confluence of art and meta-cultures within it.
Sussman's biennial was shocking because it introduced multiculturalist
artists living in and outside New York City at a time when formalism
was still exalted. It emphatically reflected the country's diversity by
including unusually large numbers of nonwhite artists, artists whose
work is openly gay, and female artists.
GM: I think it's very important to remember that the Global South is also
right here in New York, or in Toronto. I mean, it's not about geography.
It's about positioning and diasporas; it's the South on the move.

/ Gerardo Mosquera

/ **José Roca**
Interview 2013

<u>Carolee Thea:</u> Given that the nature of the biennial was once character-
ized only by national pavilions, it is significant that the 55th Venice
Biennale (2013) exhibited a noticeable decentering. France showed
work by the Chinese artist Ai Weiwei, for example, and Germany
featured the Albanian artist Anri Sala, who lives in Berlin.
It appears that a growing internationalism, whether fueled by the
concept of diaspora or not, is opening more avenues to explore what
is the national. Each country, as it deals with globalization, demon-
strates a sort of self-appointed authority or privilege by exhibiting
international art, which is to say—unsurprisingly—that such nationalist
decentering comes, once again, from the center.
Nonetheless, change is happening, as we see in São Paulo, where in
2006, the Bienal abandoned the concept of national representations
and the long-contested selection process for the chief curator was
overhauled.

José, please describe how these changes came about.

<u>José Roca:</u> For many years, the local art scene in São Paulo had been
demanding a more transparent way of choosing the curator of the Bienal,
and finally a national competition was held among four Brazilian curators.
Their proposals were weighed by a committee and an external panel, who
chose one curator, the Brazilian Lisette Lagnado. She worked with a cura-
torial team consisting of Adriano Pedrosa, Cristina Freire, Rosa Martínez,
and myself. Jochen Volz was guest curator. All of us were in charge of
selecting the 118 international participants.

<u>CT:</u> In her curatorial statement, Lagnado said that this Bienal exhibits
"a freedom from the great geopolitical machine ruling the decisions
of a cultural bureaucracy to level the playing
field for the works on display."

<u>JR:</u> The older model was said to have nurtured cul-
tural or geopolitical hegemony. In this version the
international representations were not eliminated
but instead redirected as per curatorial decisions.

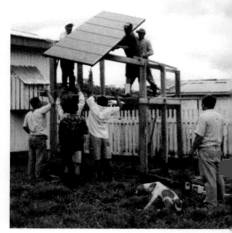

<u>CT:</u> The exhibition title, *Como viver junto* (*How
to Live Together*), was borrowed from Roland
Barthes' lectures at the Collège de France in
1976–77. The curators said, "An ethical defi-
nition of Living Together shall be searched
through the conceptual emphasis of the con-
struction of shared spaces, the questioning of
coexistence, differences, rhythms of produc-
tion and cooperative practices."

<u>JR:</u> Staying cognizant of its national context, the
show remained international. Instead of the artists

/ **José Roca**

(pages 30–31)
FLORA ars+natura, Bogotá, Colombia,
2015. Installation by Carlos Garaicoa,
Diferentes maneras de cruzar un río,
2014. Courtesy the artist and FLORA
ars+natura. Photo: Gonzalo Anagita

being chosen by their national institutions, the curators chose artists from various countries and asked them to work with Brazilian issues.

For example, the state of Acre, located in the Amazon jungle, formerly was Bolivian land occupied by Brazilian rubber-tappers during the height of the rubber boom, from the 1880s to the 1920s. When rubber became scarce in the area, workers went into the jungle and stayed there. In 1899 the Bolivian government sent the army to oust them, and the prospectors rebelled and declared Acre an independent republic. This only lasted for three years and then Acre was annexed as a state of Brazil. In 2005, leading up to the Bienal in 2006, I was in charge of the artists who would do long-term residencies in Acre.

CT: Tell me about these artworks.

JR: The Slovenian Marjetica Potrč went into the jungle and traveled the Juruá River, where she spent time with the community that was living there. She built a house with solar panels and an Internet connection. Yeah, modern updates, but it was up to the community itself to deal with this, to understand their isolation as a positive condition, and to connect with the "outside world" when and how they chose. The concept centered on what it entails to be a citizen of the jungle. So instead of trying to bring outside Western knowledge as the last word, that is, viewing culture as inevitable progress, her project honored what was already there. The initial idea was to teach the knowledge that comes from the jungle itself, such as jungle medicine and other ideas and skills that had been passed on for generations among the indigenous people.

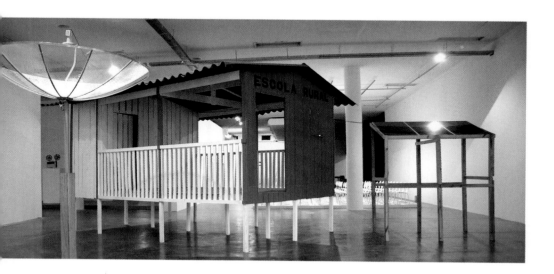

Marjetica Potrč, *Xapuri: Rural School*, 2006. Building materials and energy and communication infrastructure. 27th São Paulo Bienal, 2006. Courtesy SEPLANDS and PRODEEM, the State of Acre, Brazil, the artist, and Galerie Nordenhake, Berlin/ Stockholm. Photo: Wolfgang Traeger

/ __José Roca__

34

Potrč also delved into the concept of *florestanía*. The Spanish word for citizenship, *ciudadanía*, means "of the city" (from the word *ciudad*, or city). So, from the Portuguese word for jungle, *floresta*, comes "jungle-ship" or citizenship of the jungle, *florestanía*.

Another project there was by the Colombian artist Alberto Baraya. Rubber is no longer an important economy in Acre, and so with the help of many idle rubber-tappers, Baraya found a 21-meter-tall rubber tree that bore the markings of several generations of tappers. He surrounded it with scaffolding and over a period of a few months it was painted with several layers of latex. It was then cut and peeled like the skin of a snake, and we showed this huge piece on a low pedestal. It was a cast of a live tree created from the very same material that it yielded in another time.

CT: Art historian María Clara Bernal Bermudez wrote, "Every generation reinvents itself and in this sense what we can see is that within the journey into globalisation art proposes a paradigm to survive homogenisation as well as complete fragmentation and isolation and that is the strategy of negotiation of space and place."[1]

As a footnote, this jungle, a remarkably remote and sociopolitically unique part of the country, was twice unsuccessfully colonized by the Ford company between 1928 and 1945. The goal was twofold: to supply Ford's internal demand for rubber and to provide a better way of life for the Brazilians who lived and worked on the plantations. The plantations were testaments to the innovations of agriculture and industry related to commercial cultivation of the jungle, and of the efforts to impose a Dearborn-like work schedule and life on the native Brazilian.

1. María Clara Bernal Bermudez, "Questions on Place and Space in Latin American Art," Latinart.com, Oct. 1, 2005, accessed July 30, 2015.

JR: Yes, the demise of Fordlandia, the pretentious name given to the town that Ford established, and of Belterra, the other ill-fated city that the company built some years later, are testimonies of the tragedy brought to the jungle dwellers by the demands of capital. But this is far from being a historical footnote: extensive deforestation for cattle and soybeans, for example, mean not only the symbolic crossing of the last ecological frontier, but also a real threat for the survival of the world. It's no longer just a Brazilian problem.

CT: In 2011 you were chief curator for the 8th Bienal do Mercosul, in Porto Alegre, Brazil. You chose to address territoriality from geographical, political, and cultural perspectives, which included notions of locality, territory, mapping, and frontier to be discovered and activated through art.

Mercosul is a geopolitical construct by the supranational organizations of the region and the city of Porto Alegre. In this biennial, as in the 2006 São Paulo show, you invited international artists to work in

regionally specific environments as a way of demonstrating alternatives to the conventional idea of nation, to discuss new cartographies and geopolitical relationships, and to reposition our understanding of the relationship between the regional and the global. This asserted itself as an ongoing educational model in the cultural landscape of Rio Grande do Sul. Working with the artist Pablo Helguera as the pedagogical curator, you collaborated on the circulation of artworks throughout this arena. Helguera has told me that the position of pedagogical curator was unusual in that it involved constructing the educational dimension of the biennial exhibition, which included joining the curatorial team in the selection of artists. The idea was to explore the places where art practice and pedagogy meet—from interpretation to education as art.[2]

2. E-mail from Pablo Helguera to Carolee Thea, Feb. 2, 2015.

/ **José Roca**

Alberto Baraya, *Rubber Tree Project*, 2006. Latex (natural rubber) cast. 27th São Paulo Bienal, Brazil, 2006. Courtesy the artist

JR: Yes. There were several distinct components of the Mercosul Biennial that took place in different parts of the region outside of Porto Alegre. What I did was to conceive the project and then invite Pablo Helguera to reshape it from the standpoint of trans-pedagogy, or education through art. So the educational part was integrated within the curatorial project and became a major aspect of our Biennial. The Mercosul Biennial has always had a strong educational component, but now it was built into the curatorial proposal from the get-go and it worked.

CT: One of your ongoing interests has been the relationship between botany and politics. Your 2000 exhibition, *Define Context*, at New York's Apex Art Curatorial Program, for example, included several artists who were dealing with coca and poppy plants.

JR: Yes, I also staged an exhibition in 2004 called *Political Botany* at the Caixa's Sala Montcada in Barcelona. It's a theme that runs through my curatorial practice. In a country like Colombia, art and nature are always cut through with politics. From the very inception of the country, scientific travelers were arriving with detailed inventories of what was there to be exploited; it was in the guise of science, but they were of course financed by colonial powers.

Pablo Helguera, *The School of Panamerican Unrest*, 2006. Socially engaged art in Tok, Alaska, May 22, 2006. Courtesy the artist

CT: You seem to highlight the uniqueness of a place, but when it is thrown out into the world, something larger takes place.

JR: In doing so, you discover or realize that your own concerns and your own preoccupations could be shared in other areas of the world. Not necessarily globally, but rather to discrete populations here and there.
For example, there are those groups who completely relate to what I'm doing because they have similar problems or issues. In 2012 I did a project called *Irregular Hexagon* in which six Colombian artists had residencies in six places throughout the world: Gertrude Contemporary in Melbourne; the Jerusalem Center for Contemporary Art; Sàn Art in Ho Chi Minh City; L'appartement 22 in Rabat; 72-13 in Singapore; and Cer Modern in Ankara.
Each independent space hosted two Colombian artists, and both encountered a new context for their work. The first, Delcy Morelos, went to Rabat and ventured out into the market and realized that everyone looked familiar to her, like a cousin maybe, and she began to think about Lebanese and North African immigration in the northern part of Colombia.
The second artist was Mateo López, who does complex installations replicating everyday objects in paper. What would seem to be a typical messy studio reveals itself as a sort of sculptural drawing installation when you realize that everything on the tables—ruled paper, pencils, scissors, erasers, etc.—has been painstakingly drawn and replicated in construction paper.
López went to Singapore and saw shirts, shoes, radios, pens, all kinds of things that were hung outside of small shops, and he later realized they were all done in paper. This is because of the Hungry Ghost Festival, where once a year people buy things to burn to symbolically honor ghosts.
There is an industry that provides anything and everything made of paper for this festival. So he was fascinated by these readymades, which he bought and incorporated in his installation, which is called *Nowhere Man*.
The tradition in Colombia and the one in Singapore had different colonial and postcolonial histories, but similar visual components. One could argue that maybe in Latin America, because we were all conquered at the same time and we all gained independence at more or less the same time, we have more or less the same colonial and postcolonial history, though that's not entirely true; nevertheless, where Singapore has an alternate history, points of contact remain.

CT: Is censorship a factor in Colombia?

JR: In my curatorial practice I have worked with artists who try to raise awareness of the difficult political and social situation, but I wouldn't say that art is instrumental in affecting that kind of change. Art is not a shock treatment; rather, it's an avenue that reminds you that there are important issues to be addressed. There have been some cases of censorship, but it's often a clumsy official who feels that his or her job is compromised by

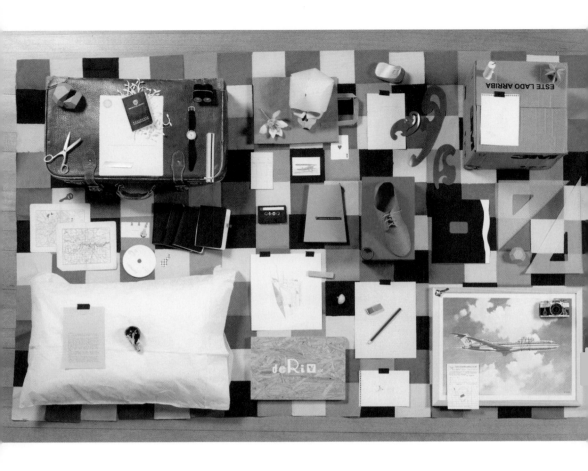

/ José Roca

Mateo López, *Nowhere Man*, 2011.
Irregular Hexagon, 2012. Courtesy
the artist and Casas Riegner.
Photos: Oscar Monsalve

potentially offensive work and decides, preemptively, to remove it from a show, but this is not an official policy of the Colombian government. The point I'm trying to make is that art, apparently in the eyes of the government, doesn't have that kind of power, and therefore it's not perceived as dangerous.

In Cuba, for example, some factions were denouncing this work or that, but in fact the artwork was tolerated by the establishment as a way to tell the world that they were tolerant, and that there was no censorship. So, they embraced dissent to send a political message. Thus, controversial art in Cuba ended up serving a purpose for the government. In Colombia, at least, art is important to open eyes and raise awareness, but it hasn't massively moved the population toward political action.

In Colombia, a well-known journalist who was also an acute political satirist was killed, and to this day the murder remains unresolved. No one really knows who did it, but it seems that his effectiveness in addressing points such as political corruption and so on led to his murder. Still, I don't think a visual artist would ever be killed because of a video or a painting or a series of photographs. Frankly, I do not believe art has the kind of power to disrupt the established order. Not in Colombia, anyway. But, as we know, the alternative—silence—is worse.

> CT: Given the accessibility of information today, visual literacy advances into the public realm quickly. Your curatorial efforts seem to feed into this via a unique and expanded sense of public awareness. During the 2011 Mercosul Biennial, for example, you created Casa M, a meeting place for the local art scene in Porto Alegre and beyond. It was based on the desire to create a temporary community around the exhibition, to promote dialogue and cultural exchange, thus creating ways of observing the other for both similarities and differences. And, at any rate, it was a way of extending the largesse of the Biennial.
>
> And now the alternative exhibition space FLORA ars+natura is a new project that you and your wife, Adriana, have created in Bogotá. FLORA focuses on curatorial residencies, small exhibitions, intimate discussions, and hands-on workshops with educational resources and community involvement. Does this represent a compendium of your ideas about nature and politics?

JR: FLORA is a cultural center in Bogotá, housed in a building we bought with our savings. We're remodeling it, and when it is completed it will be a small independent space with an auditorium, a library specializing in contemporary art (particularly art and nature), a project room, and several studios, which are given for free to the artists as year-long grants. My wife and I also have another house, four hours outside of Bogotá in the historic city of Honda (named after the indigenous people who lived there before

/ **José Roca**

the Spaniards came). That house now serves as an extension of the
FLORA project, as the site for residencies.

CT: How did your collaboration with your wife come about?

JR: She's a lawyer and worked in tax and customs law. For the last six
years she's been working for the city of Bogotá in the Secretary of
Culture's office and now in the Ministry of Culture, drafting policies that
benefit the cultural sector. She is now the executive director of FLORA.

CT: How was this project funded?

/ José Roca

FLORA ars+natura, Bogotá, Colombia,
2015. Photo: Gonzalo Anagita

JR: The model is one that I'm devising, which is that with my savings I created the space and I am using my curatorial work to provide content. So every time I'm invited to do a project, I do it on the condition that the project's sponsor funds a month-long residency for an artist at FLORA. The response has been surprisingly positive: I already have more than 10 residencies fully funded.

CT: There are many institutions or spaces today that have residencies funded by the government.

JR: Yes, but this is different. In my case, I'm doing my job as a curator, and it's also a funding exchange.

CT: I'm curious about the changes taking place in the biennial model. Mostly, detractors don't understand the biennial as a living thing that morphs over time. That said, it seems as if smaller, alternative, or privately owned spaces like FLORA make up for what these big exhibitions lack, by allowing for quicker responses to the shifting expansion of, and the discussions within, the local or endemic art worlds.

JR: Right. The Venice Biennale doesn't change much, but when I talk about the biennial model I always think of the Bienal de São Paulo building in Ibirapuera Park. It is like a huge transatlantic vessel, like the Bienal itself, whose course the curator can change only by degrees. The inertia is so strong that you can't turn it around. So you rework the model, but you accept some of its givens.

CT: It's not a revolution. It's an...

JR: ...evolution.

CT: Do you want to curate another biennial?

JR: No. I said publicly that I wouldn't do any more biennials, because the 2011 Mercosul Biennial was the eighth biennial-type project that I did, including the print triennial in Puerto Rico with Mari Carmen Ramírez; the two urban interventions in Cartagena and Valparaíso; the Encuentro Internacional de Medellín in 2007; Philagrafika, the print triennial in Philadelphia, in 2010; the Bienal de São Paulo in 2006; and the Bienal Paíz, Guatemala, in 2010.

I've done so many projects—both large biennials and smaller biennial-type events—that I think I've said what I had to say. The Mercosul Biennial was, for me, a curatorial collage. I took things that had worked in previous projects and, with this in mind, I put together my proposal. That kind of curatorial practice, you could say, is a sort of corrected readymade. I put out everything I thought a biennial should be. In fact, I wrote a 20-point declaration of principles, which I called the "duo-decalogue," of what I thought a biennial shouldn't be. I posted it on the Biennial's blog and I've tried to abide by that code of conduct in my practice as a curator.

/ **José Roca**

/ **Bisi Silva**
Interview 2014

Carolee Thea: I'm interested in your work as the founder/director of the Centre for Contemporary Art, Lagos, Nigeria, as well as in the international exhibitions you've curated. Your prominence in the art world has grown dramatically in the last decade; everyone seems to know you. What was your first major experience in curating?

Bisi Silva: My first major curatorial undertaking after moving to Nigeria was as a member of the Dak'Art Biennial curatorial team in 2006. I was invited by the artistic director, Yacouba Konaté, with individual members responsible for specific areas: West Africa, North Africa, Southern Africa, and the African diaspora.

It was very stimulating. There was a budget for travel, which allowed me to go to three countries in West Africa: Cameroon for one, where the Douala art scene was lauded and well known. I did studio visits there—they were extremely enriching and stimulating. I also journeyed within Nigeria and to Ghana. Moving across West Africa got me closer to understanding the conditions in which the artists work, their support systems, and the critical discourse within in each country. This trip was extremely important because I learned how contemporary African art was presented and disseminated locally.

Africa is made up of many countries and we talk about African artists without engaging the local dynamics that actually create these artists. Questions such as: What's it like working in Douala? What are the historical, political, and social conditions that impact the work the artists are making? What are the difficulties they encounter? What are the support systems that exist for them? You would never write about this without at least localizing or contextualizing the space in which the work is created. Then, of course, coming to Dakar and engaging with my colleagues from other African countries was rewarding.

CT: In 2009 you were invited to be on the curatorial team for the 2nd Thessaloniki Biennale, where you worked with Gabriela Salgado, an Argentinian curator based in London, and Syrago Tsiara, the Greek director of the Thessaloniki Contemporary Art Center. Beginning with its title, *Praxis: Art in Times of Uncertainty,* the Biennale claimed to be responsive to a number of complex events—the collapse of colonialism and the Soviet bloc, and the presumed failure of Modernism!

BS: This was an illuminating experience. In addition to inviting established international artists, we each brought our experiences from our own regions or research interests. I focused on Africa, Gabriela Salgado on South America, and Syrago Tsiara on the Balkans. The cross-fertilization of ideas and projects was stimulating and one of my most fulfilling and critical intellectual projects.

The aim here was nothing less than a radical alteration of individual and social relations. *Praxis* emphasized engagement with the local trading port

(pages 42–43)
Kimsooja, *Mumbai: A Laundry Field*, 2007–8. Four-channel video installation, sound, 10:25-min. loop. 2nd Thessaloniki Biennale. Courtesy Kimsooja Studio. Photo: Pradeep Bhatia

community while keeping an eye on the city's position in a country torn by
riots the previous year. The fifteenth-century Bey Hamam, the Baths of
Paradise, close to the city center, contained the most consistent selection
of work. Melanie Manchot's *The Dreamcollector* (2008), comprised several
videos in which the artist asked people found sleeping in public spaces,
on waking, to recount their dreams to the camera. Kimsooja's four-channel
video *Mumbai: A Laundry Field* (2007–8) offered a less heavy handed
approach to social engagement.

We showed works by more than 150 artists from 40 countries in three main
spaces around the city's port as well as additional venues—bookshops,
hamams, public squares, and museums—which hosted parallel programs
of events, actions, and smaller contextualizing exhibits.

> CT: Today there is a preponderance of influential curators who are
> female. This was not the case in 1997, when I began interviewing
> curators.

Melanie Manchot, *The Dreamcollector*,
2008. Five-channel video installation, 43
min. 2nd Thessaloniki Biennale. © Melanie
Manchot; courtesy Galerie m, Bochum,
Germany

/ Bisi Silva

BS: Interesting! Maybe within the African context, it has to do with the way in which the arts are viewed. I think it's the more organizational side of the arts that has somehow fallen to the women, and the more artistic side, the art making, seems to be, or was, male-dominated. Even when I look at the history of art in Nigeria, there were two early women artists, Theresa Akinwale and Clara Etso; both went to art school in the U.K. in the '50s, and to a certain extent they've been written out of Nigerian art history and need to be reclaimed. However—and up until the mid-'80s, I would say—there were very few visible Nigerian women artists, but now there are many.

> CT: We're doing this interview today during the 14th Dak'Art Biennial, in Dakar, Senegal. Do you consider this as *the* major biennial on the African continent?

BS: Yes, it definitely is, but there are others: Bamako Encounters: African Biennial of Photography, in Mali (recently interrupted because of the political situation); one in Cairo (which has been going for nearly two decades); the Johannesburg Biennale (which had only two editions, in 1995 and '97); the Cape Town Biennial; the Marrakech Biennale; and, recently, Picha, the Lubumbashi Biennale, in the Democratic Republic of Congo; and the Luanda Triennale, which I think is coming up to its third edition. The Luanda Triennale was started by the Angolan artist and curator Fernando Alvim with the collection of Sindika Dokolo, with Simon Njami serving as advisor/co-curator.

> CT: Sindika Dokolo is probably the singular person who helped establish the Triennale.

BS: Yes. His collection forms the basis of what is shown during the Luanda Triennale, but the exhibition has more to do with reaching out to the city. It reclaims a lot of spaces throughout the city of Luanda that have been destroyed or abandoned during the country's civil war. Some of them are renovated, especially old buildings, and the artists work in these spaces. It's not only visual art, but also fashion, music. It's a huge cultural festival. It does include some non-African artists, but it's principally African art from Africa and from around the world. Global Africa. I'll call it a global Africa collection.

> CT: Isn't it true that Dokolo is one of the supporters of the new curator from Africa at the Tate?

BS: Not to my knowledge. Elvira Dyangani Ose was selected in 2011 as curator of international art. Her position is supported by the Guaranty Trust Bank of Nigeria.

> CT: Since 2007 one of your most important positions has been the directorship of the CCA—Centre for Contemporary Art, Lagos— curating exhibitions and organizing projects with national, regional, continental, and international artists, curators, and institutions.

BS: My focus has been on contemporary art and, within that, my area of interest and research is Africa and the Global South.

CT: What motivated you to open an independent art space in Lagos?

BS: In 2006 the contemporary landscape was at an embryonic stage. In Lagos there were a few galleries but mainly commercial ones. I started CCA, Lagos, to provide a platform and a space for artists who were more socially engaged and experimental in their practice—artists who may not appeal to a very conservative collector base. In other parts of the region there are Doual'art, started by Marilyn Doual Bell and Didier Schaub, and ArtBakery, an initiative of the late artist Goddy Leye. He had studied in Amsterdam and returned to set up this residency space for video art in Bonendale, a suburb of Douala, in Cameroon.

Such organizations have impacted their local art context in important ways, many in the face of total governmental inaction. Whilst Doual'art has been active for about 20 years, several new organizations such as RAW Material, Dakar; Centre for Contemporary Art, Lagos; and Nubuke Foundation, Accra, have been initiated over the past decade across the region. Amadou Chab Touré, director of Maison Carpe Diem, Ségou, Mali, opened the only photography gallery and bookshop in Mali in the early 1990s. These organizations have also collaborated with artists and curators whose work engages or explores the idea of the city.

CT: Tell me about the CCA: What was your inspiration for opening the space, and for its mission?

BS: I had lived most of my life in the U.K. and returned to Nigeria in 2002, where I found a dynamic art market made possible by Nigerian and expatriate collectors, as well as the big industries in Nigeria: telecommunications, finance, the oil industry (Nigeria is the largest oil producing country in Africa), and the burgeoning hospitality industry (hotels buy art and commission artists for their lobbies). Nigeria has become the largest economy in Africa, overtaking South Africa.

I am the founder (2007) of CCA and its artistic director. We do group exhibitions, thematic exhibitions, solo exhibitions, talks, workshops, and a variety of programs that engage older artists, emerging artists, and writers, as well as filmmakers and anyone who's interested in art and culture. There's a library on another floor, which has grown incredibly over the last six and a half years from the 300 or so books that we started with to over 6,500 books, videos, journals, and ephemera. We work with artists in Nigeria, across Africa, and internationally, but we also collaborate with international organizations to bring projects to a Lagos audience. This is where everything begins for me—I consider myself a Lagosian!

CT: ...and a feminist?

BS: I strongly support female visibility and identity in a platform that allows women artists to articulate their views. You know, of course, that we do

/ **Bisi Silva**

have a problem in the visual arts. In much of the work that comes out of Nigeria and other African countries, women are depicted as paragons of beauty, the upholders of family and other very traditional values and perspectives, but what is not taken seriously is the complexity of their experiences, their thoughts, their wishes, and their desires. So, yes, from that perspective, I am a feminist!

CT: You also edited an issue of *n.paradoxa*, an international feminist art journal, that highlighted the work of women artists from Africa and the African diaspora.[1]

1. *n.paradoxa*, "Africa and Its Diasporas," vol. 31, Jan. 2013.

BS: It was fascinating to include an array of contributions and articles by artists on the African continent, in Europe, America, as well as South America. In Brazil, for example, it was important to expand the boundaries of what we think of as the diaspora, locating it beyond the Euro-American access. This is especially pertinent for Brazil, which supposedly has the largest black population outside of Nigeria.

CT: Why is it different in Brazil?

BS: The trajectory and the position within a democratic Brazil is completely different from America, Europe, or even Africa. In Brazil the concept of race has not been engaged the way it has in Europe or in the U.S. They are still beholden to an early-twentieth-century ideology of a "racial democracy" as articulated by Brazilian sociologist Gilberto Freyre. But this idea of a racial equality is a fallacy and attempts to obviate the deep inequalities at the end of slavery and that continue today.

CT: Are the politics of feminism supported in Lagos?

BS: For many years I've found that—at least in the visual arts, unlike maybe literature—few women publicly accepted or declared their work to be part of any feminist movement or thinking. In fact, I think there was the rejection of feminism as a Western construct that did not take into consideration their cultural and traditional beliefs, and even less their daily realities. Women have always worked, whether it was on the farm or in other informal economies, such as sewing, making and selling food, textiles, etc. And most do believe that the woman looks after the family, but as you know, looking after the family is a collective affair, assured by the extended family unit, and not a solitary endeavor.

I curated an exhibition at CCA, Lagos, in 2008–9, *Like a Virgin*, with two young African artists, Lucy Azubuike from Nigeria and Zanele Muholi from South Africa, dealing with the body and sexuality. Of course, in South Africa they'd already begun debates around the body, sexuality, and gender. But in Nigeria it was an extremely new topic within the visual arts. In literature, however, it has been more open, as many women writers have been quite articulate in writing and discussing their positions.

Lucy Azubuike, *The Whisper*, 2006. Menstrual blood on tissue paper. *Like a Virgin*, Centre for Contemporary Art, Lagos, 2008–9

/ **Bisi Silva**

Zanele Muholi, *Flesh*, 2005. Photograph. *Like a Virgin*, Centre for Contemporary Art, Lagos, 2008–9. Courtesy Stevenson, Cape Town and Johannesburg

/ Bisi Silva

CT: How was *Like a Virgin* received?

BS: It was quite provocative, pioneering, and confrontational. Muholi is a South African artist/photographer and lesbian activist, and Azubuike's work deals with the tension between modernity and tradition as it relates to women through photography. I had been introduced to Azubuike by El Anatsui, who was like a mentor to her. Azubuike's piece was a menstruation series, a visual diary she showed to only Anatsui because she didn't think it would be appreciated within a commercially driven Nigerian art context.

CT: How long had she been working on it?

BS: For about eight years, and she was quite surprised when I visited her studio. And really this was the first time that a discussion of the body and sexuality happened in Nigerian art.

CT: In Lagos, how would you describe the reception around the politics of feminism?

BS: Actually, this piece was quite well received, at least during the presentation, but the messages in the visitors book were mixed, from "This is the most disgusting, horrible thing. Why do you want to show this?" and "I don't want to come into a gallery and see it" to "Congratulations, it's about time that this was brought into a public arena instead of being swept under the carpet." Frankly, I think it's the women who are sometimes the most averse to this discourse.

CT: Given the extreme Muslim impact in Nigeria, are you able to speak of Lagos and the rest of Nigeria in the same tone?

BS: There's outrage throughout Nigeria regarding the Boko Haram situation. Everybody is anxious. Every mother fears for her child. But as this tragedy isn't happening in Lagos, I feel there's a little bit of detachment. For sure, though, any injustice toward women and young girls is seen with outrage by both men and women.

CT: Are the artists protesting around this issue?

BS: They are to some extent, but I don't think it is enough considering the gravity of the situation. We have socially engaged artists: recently, there was a big issue around child brides and many female (and male) artists did performances and installations confronting that. In fact, a male artist named Jelili Atiku did a critical performance in the streets that engaged this issue. He created a mock wedding with a young girl and walked with his new (underage) bride through the streets of Lagos.

CT: Hmmm! What is the nature of art training in Lagos?

BS: Today you'll find that because we're a former British colony, most artists in Nigeria have been trained in an academic art system, one that is based on the Slade Art School system, the traditional British colonial art system of the 1950s and '60s. This is true across all the former British colonies, including Ghana and Uganda. Art training needs desperately to

/ **Bisi Silva**

be updated, and small moves are being made in this direction, but it is still too slow, putting artists at a disadvantage in the twenty-first century.

CT: According to the German art historian Hans Belting, "Beyond the West, contemporary art has a very different meaning that is slowly also seeping into the Western art scene. There, it is hailed as a liberation from modernism's heritage and is identified with local art currents of recent origin. In such terms, it offers revolt against both art history, with its Western-based meaning, and against ethnic traditions, which seem like prisons for local culture in a global world."[2]

BS: In the early '60s, at the time of the development of the art academy, we had a group of artists called the Zaria Rebels, who came from the fine art department of the Ahmadu Bello University in Zaria. These artists formed a collective to challenge the British colonial art education system, one that omitted their own history. They wanted to see themselves reflected! They wanted to learn about Queen Amina of Zazzau, who in the sixteenth century was a West African warrior queen, and they wanted to incorporate their Yoruba and Benin culture into their art. The educational system has changed somewhat but not enough.

2. Hans Belting, "Contemporary Art and the Museum in the Global Age," lecture delivered at "L'Idea del Museo: Identità, Ruoli, Prospettive," conference held Dec. 13–15, 2006, http://www.forumpermanente.org/en/journal/articles/contemporary-art-and-the-museum-in-the-global-age-1, accessed Sept. 20, 2015.

/ Bisi Silva

Jelili Atiku, *Senator Yerima's Wedding*, 2013. Performance, August 10, 2013. Courtesy the artist. Photo: Tyna Adebowale

/ Ugochukwu-Smooth Nzewi
Interview 2015

Emeka Ogboh, *Lagos Soundscape_
Recording Yaba*, 2014. Photograph.
© Emeka Ogboh

<u>Carolee Thea</u>: Prior to your museum studies in South Africa, you trained as an artist at the University of Nigeria under El Anatsui, whose work is a commentary on globalism, consumerism, and the cultural, social, and economic histories of West Africa. What was it like to work with him?

<u>Ugochukwu-Smooth Nzewi</u>: El Anatsui was already a big deal when I was a student, but he had not achieved his current stratospheric fame. So while we knew he was an important sculptor and very much enjoyed his quiet prodding to explore unconventional materials and forms, he was still very human to us (myself and other sculpture majors).

<u>CT</u>: Did his teaching influence your curatorial work?

<u>U-SN</u>: Not at all. His teaching came in handy in one or two classes outside of the studio, where he discussed the broader aspects of artistic professionalization.

I would say that my interest in curatorial work began almost immediately

/ **Ugochukwu-Smooth Nzewi**

El Anatsui, *Dusasa II*, 2007. Found aluminum and copper wire. 2007 Venice Biennale. © El Anatsui; courtesy the artist and Jack Shainman Gallery, New York. Photo: Giovanni Pancino

after college. I was fortunate to find myself in a circle of entrepreneurial artists who were organizing exhibitions and art events in the absence of a real institutional structure for contemporary art in Nigeria. It was while I was affiliated with these colleagues that I found my passion for curating.

CT: There is an ongoing discussion about artists as curators. Can you comment?

U-SN: In the last few years the so-called independent curator has become increasingly powerful as a shaper of artistic trends and currents. I would not be the first to observe this state of things.

But saying this tongue-in-cheek, some curators are fairly insecure around artists, and hence have the tendency to be dictatorial. Not infrequently the curator's personality or ideas take center stage instead of the artist or artwork. In such a situation the artist becomes, if you will, a prop, an object of the curator's fantasy. There is bound to be pushback from artists seeking to reassert that they are fundamentally the core of the art world. As such, we are beginning to see artists, increasingly, curating major international exhibitions, reinserting themselves into the conversation in a more visible way.

CT: Dictatorial? Hmmm! When the writer, critic, and former painter Francesco Bonami became artistic director of the 50th Venice Biennale and titled it *Dreams and Conflicts—The Viewer's Dictatorship*, perhaps he was addressing this issue?

U-SN: Yes, in a way. Bonami's approach was to allow the viewer to make sense of the artwork in an exhibition/display context without the curator's authorial interpretation. Possibly Bonami's interest was in cutting out the curator as the middleman, the mediator, of the aesthetic experience. Yet his approach, on one hand, is still invested with a curatorial logic, in that he poses or mediates an alternative way of encountering the object. On the other hand he fails to reinstitute the artist at the heart of the aesthetic experience. In fact, what he does is akin to the "death of the author," where both the artist and curator are not needed. There is a sort of false Greenbergian formalism, if you will, underpinning this approach, whereas you and I know that the work of art embodies a set of intentions that, arguably, provides clues for a richer aesthetic experience.

CT: Since its founding in 1992, Dak'Art, the Dakar biennial, has been described as a "natural extension of a sum of reflections and actions carried out by intellectuals and culture experts from Africa and the diaspora" with a distinctly social standpoint.[1]

U-SN: Dak'Art's formal emergence in 1989 as a biennial of literature and art (it became solely an art biennial after 1992) was dictated by Senegal's policy of cultural diplomacy. It follows a trajectory of grandiose cultural

1. Http://www.biennialfoundation.org/biennials/dak'art-the-biennial-of-the-contemporary-african-art, accessed July 31, 2015.


events initiated and executed by the state to promote the image of the country as a bastion of modern culture and democracy. It is the largest art biennial in Africa today, with a mandate to include artists of African descent.

The 11th edition, which I co-curated in 2014, was titled *Producing the Common*. The selection of artists was divided among three curators: Elise Atangana, Abdelkader Damani, and myself. We were each given a geographic territory of Africa: north of the Sahara; south of the Sahara; and the diaspora. The exhibition showed over 120 artists, revealing a daunting diversity of artworks, styles, and traditions, with its main international showcase at the Village de la Biennale, a television studio along Route de la Rufisque in Dakar's industrial area. There was also a huge section listed as OFF, which is independent of the official exhibitions and curators.

> CT: In the show's statement, all of the curators express their "hope to reflect together on art and politics," and you assert that "being together is the only horizon for humanity." How did this theme play out?

U-SN: Our theme, Producing the Common, attempted to discuss globalization in a new way, through African-inspired ideas of communalism—what folks in southern Africa will call *ubuntu*. The *ubuntu* philosophy simply means that one is human because of his neighbors. On another level art biennials are political platforms geared toward achieving some cultural aims. This is to say, they pursue specific agendas.

For this reason, we were interested in the relationship between politics and aesthetics, and therefore drew on Jacques Rancière's theory of the "common." We also considered Michael Hardt's reexamination of Rancière's articulation against the backdrop of the neoliberalism of the contemporary art world, and art biennials as vehicles of cultural globalization.

I believe that the Dak'Art 2014 international exhibition allowed one to chew on notions of *ubuntu* as well as Rancière's and Hardt's positions. It was very important to us to position Dakar at the center of the art world, and to approach the state of our contemporary world through an African lens. On a personal level, as curators, we worked collaboratively in selecting artists despite each of us being given a geographical territory to supervise. We could not have been preaching "Producing the Common" and then choose to work separately.

> CT: Not without sounding like total hypocrites!

U-SN: Exactly! So we decided collectively whom to select from the submitted portfolios, and whom to invite to submit portfolios. We also chose an additional eight artists per curator.

> CT: Of the chosen 61 artists, which ones were among the most outstanding unfamiliar participants?

U-SN: Samson Kambalu, from Malawi. He is the second artist from Malawi

to ever show in the Dak'Art Biennial. He exhibited two films, *Early Film* and *The Last Man in Paris*, in which he performs the part of an African immigrant living in Europe.

Another artist is Rashid Ali, originally from Somalia, working collaboratively with British photographer Andrew Cross. They produced a deeply disconcerting video and photographic series called *Lost Moderns*. They explore Mogadishu through its architecture and urban environments, contextualizing the city's current schizophrenic state of precariousness and normalcy, and the broader colonial and postcolonial histories of Somalia.

CT: Do you think a biennial in Dakar has an audience beyond the people who live there?

U-SN: When curating the biennial we focused on both the local and international audience. It is important to state, however, that all art is connected to local communities and, of course, there is no art that can escape being called "local." Inasmuch as we often want to describe an artist in the West—New York, for example—as operating within a more internationalized context, that artist is emplaced in a local art situation. He or she is no different from an artist in New Delhi or Lagos who engages or understands the international through the immediate local context. Whatever an artist produces is first informed by the immediate social and cultural realities of his or her specific locale.

Emeka Ogboh is an artist I greatly admire. He lives in Lagos, Nigeria,

/ **Ugochukwu-Smooth Nzewi**

Samson Kambalu, *Bacchus*, segment 1
of *The Last Man in Paris*, 2013. Video.
Dak'Art Biennial, 2014. Courtesy the
artist

although he is currently working in Berlin as a DAAD (Deutscher Akademischer Austausch Dienst) fellow. His work has focused primarily on the acoustic character of Lagos's economic hub. In the last few years he has taken Lagos soundscapes as a point of departure in exploring those of other world cities, including Berlin, Helsinki, and Tokyo. He is able to universalize Lagos's acoustic presence by finding connections to soundscapes from elsewhere. In that sense the local is global and vice versa.

CT: What can you tell me about patronage in African contemporary art?

U-SN: I explained to someone recently how local patronage works in Africa, in that prices vary in accordance with the purchasing power in individual countries. For example, if a Senegalese artist might be able to sell an artwork in Senegal to a local collector for $10,000, an artist of similar status might be able to sell his or her work for twice that sum in Lagos or Johannesburg because the art market in those places is bigger. There is also international patronage—lots of collectors come to Dakar during and after Dak'Art. The city is a gateway to, at least, the West African coast, and Senegalese artists have benefited from its strategic location as a cultural hub. All this is to say that there are two types of collectors of contemporary African art: the local patron whose purchasing power is contingent on the collecting practices of the country in question; and the international collector who is responding to the international art market's growing interest in contemporary African art.

/ Ugochukwu-Smooth Nzewi

Andrew Cross and Rashid Ali, *Mogadishu*, 2013. Digital photograph. Dak'Art Biennial, 2014. From *Mogadishu – Lost Moderns*, commissioned by The Mosaic Rooms/AM Qattan Foundation

In Nigeria local collectors now buy from the secondary market as a result of the growth of art auctions there, which has emerged in the last 10 years or so. Modern and contemporary Nigerian art now attracts higher prices on the secondary market, and most of the transactions are made by Nigerians who are now showing more appreciation for Nigerian art as commodity. This has impacted the value of modern and contemporary Nigerian art on the international market. A ready example is the work of the pioneer modernist Ben Enwonwu (1917–1994). In the last few years the value of his work has risen steadily in the international market as result of the secondary market in Nigeria. It is a new fad, and Nigerians are faddish.

CT: It sounds like a collectors club.

U-SN: Yes, and consequently the value of Enwonwu's work, as well as that of midcentury modernists such as Bruce Onobrakpeya, Yusuf Grillo, Uche Okeke, and even second- and third-generation artists, has gone up. Last year a work by Enwonwu from the 1950s sold for a record sum of £350,000.

CT: I can imagine that collectors shop strategically in cheaper markets in order to find a discount, or that a more prestigious market would tempt a collector to pay more.

U-SN: But there are other factors, too. We know that the rise in the value of Chinese art was occasioned by a spike in the interest of Chinese collectors. Bringing it closer to home, when South African collectors began to show an interest in the pioneer modernists such as Gerard Sekoto, Ernest Mancoba, and George Pemba, to mention a few, the value of their work skyrocketed in both the South African and the international markets. This is to say that when an artist begins to be valued by his or her own country, it translates internationally. That is what happened to Chinese art. Value comes from home.

CT: Contemporary African art is becoming part of an increasingly globalized system. What are the ramifications of this trend?

U-SN: Actually, it is very positive. There are many gains as a result of this development. We take it as a given that other art worlds are part of the globalized art system. But when it comes to Africa, it is addressed as novelty or hype, which is rather unfortunate.

Notwithstanding, it is particularly interesting to note that African curators and art historians are at the forefront of this development. It was a journey that took on a new dimension in the mid-1990s, when people like Simon Njami, Okwui Enwezor, Olu Oguibe, and Salah Hassan began the charge to force contemporary African art into international consciousness. It goes back to the African proverb famously recalled by Chinua Achebe that, "until the lions have their own historians, the history of the hunt will always glorify the hunter."[2]

2. Jerome Brooks (interviewer), "Chinua Achebe, The Art of Fiction No. 139," *The Paris Review*, winter 1994, http://www.theparisreview.org/interviews/1720/the-art-of-fiction-no-139-chinua-achebe, accessed July 31, 2015.

/ Ugochukwu-Smooth Nzewi

Gerard Sekoto, *Soka Majoka*,
1946–47. Gerard Sekoto/DALRO,
Johannesburg/Licensed by VAGA,
New York, N.Y.

Nomusa Makhubu, *Lover*, 2007
(First Edition) / 2013 (Second
Edition). Digital print on archival
Litho paper, from *The Self-Portrait
Project*, Hood Museum of Art
Collection. Courtesy the artist

/ Ugochukwu-Smooth Nzewi

<u>CT</u>: So now Africa is writing its own art history, and this is evidenced, for one, by your appointment as the first curator of African art at the Hood Museum of Dartmouth College. Have you been able to collect modern and contemporary African artists?

<u>U-SN</u>: Yes, and this is a major focus of mine—to fill the gaps in our collection.

<u>CT</u>: Who are some of those artists?

<u>U-SN</u>: We have been able to acquire major works of Ibrahim El-Salahi, Owusu-Ankomah, Victor Ekpuk, Candice Breitz, and Nomusa Makhubu, among others.

<u>CT</u>: The exhibition *"Primitivism" in 20th Century Art*, curated by William Rubin of The Museum of Modern Art in New York (1984), was quite disturbing; the way objects were labeled and displayed was a colonialist enterprise. Artworks were presented not according to their original function but in terms of how they had been "milked" by Western artists. In 1989 MoMA's incorrectness was supposedly amended by curator Jean-Hubert Martin with his exhibition *Magiciens de la terre*, held at the Centre Pompidou and the Grande Halle at the Parc de la Villette, in Paris. Where Martin's show claimed to present Western and non-Western works on an equal footing, for many the title itself compared the non-Western with the irrational and exotic!

<u>U-SN</u>: Yes, as conjurer-magicians. But even with this change in language, there was still the same problem. The act of conjuring was equated with the cultural production of a Western avant-garde, in order to demonstrate tribal art's many affinities with modern art.

What museums try to do is to contextualize objects according to region or functionality. At the Hood my proposal is to let objects dance in a different way by mirroring the social imagination of African peoples in a very active sense. When I say "dance" I mean it in a metaphorical sense. I'm mindful of the danger of a literal translation of "dancing African objects," which, for want of a better term, is suggestive of a mysterious or mystified African experience or history conveyed through those objects. When I say "social imagination in an active sense" I really mean an honest engagement with the African experience in ways that Africans can relate to, in ways that they see themselves in all their triumphs and challenges, and not the way the "museum" circumscribes such experience to jibe with received notions of Africa for a mainly Western audience.

/ Ugochukwu-Smooth Nzewi

/ **Koyo Kouoh**
Interview 2014

Carolee Thea: The scarceness of contemporary art museums in post-
colonial Africa has led to a groundswell of independent artist-run or
curator-run spaces. Please tell me about the one you established in
Dakar, Senegal, RAW Material Company.

Koyo Kouoh: I had an idea, maybe it was a fantasy or a utopia, of a communal
driving force, but every independent venture of this kind derives from
its own culture, environment, tradition, needs, and practices. And we're
all different.

RAW Material Company itself is an oasis that came about from a need for
thought, recollection, inquiry, research, and contemplation. In the context
of postcolonial culture, Dakar is a very discursive city, abundant with intel-
lectual and philosophical debate that relates to politics, economy, social
life, and the poetics of human interaction. Although it was safe for the
now-defunct conversational forums of the Laboratoire Agit'Art and the
lectures organized by the late playwright Oumar Ndao, when I founded
RAW Material Company there was no recognizable place for contempo-
rary visual artists to discuss their practice in relation to their immediate
artistic and intellectual environment. Of course, there are other art-driven
arenas in Dakar, but many are so polluted with decorative perspective
and mercantile necessities that the art usually drowns.

CT: Are you referring to commercial art galleries?

KK: To a certain extent yes. Even straightforward commercial art galleries
cannot thrive by dealing in contemporary art only; the local market is not
strong enough. The people who buy art often get the works (cheaper)
from the artists directly, creating a situation that strongly undermines the
role of the art dealer. So commercial galleries tend to deal more with craft,
which is the origin of art. I was, however, interested in providing a space
for the discussion of art on a theoretical and critical level, and in artistic
practices that have relevance to politics and society.

CT: In London in 2013, running parallel with the Frieze art fair, there
was an African art fair called 1:54. As an African fair it was the first of
its kind in Europe and one that you were involved with. How did this
come about?

Kader Attia, *The Repair from Occident
to Extra-Occidental Cultures*, 2012,
detail. Mixed media, Documenta 13,
2012. Commissioned and produced by
Documenta 13 with the support and
courtesy of the artist, Galleria Continua
San Gimignano/Beijing/Le Moulin, Galerie
Krinzinger, Galerie Nagel Draxler. Further
support by Fondation Nationale des Arts
Graphiques et Plastiques, France.
Photo: OAK Studio

KK: When Touria El Glaoui, the founder of the fair, approached me three years ago to become part of 1:54, I told her from the beginning that my contribution would be primarily in the field of the discussion of art. Although I recognize the importance of the market, this is not my primary interest. I supported this project because I am conscious of how important it is for African artists and galleries promoting African art to reach an international audience—I know that many of these galleries will hardly ever be accepted at Art Basel, Frieze, or the like; therefore this international platform is vital for them. While I sit on the selection board of 1:54, my primary responsibility is to feed a platform, FORUM, where contemporary artistic practice is discussed from an African perspective.

CT: Tell me about your involvement with Documenta.

KK: Documenta 13, the most recent, was actually my third involvement in the curatorial process of a Documenta. While Carolyn Christov-Bakargiev's curatorial advisors, such as Chus Martínez, were more deeply involved, people like myself dealt only with the presentation of those artists that we suggested for participation. I worked more extensively for Documenta 11 as a research assistant for Okwui Enwezor in 2002 and far more curatorially for Documenta 12 with Roger Buergel and Ruth Noack in 2007.

When the invitation to collaborate on Documenta 13 came in, it was quite clear to me which artists I would invite. Kader Attia, an Algerian-French artist based in Berlin, whose practice investigates historical misunderstandings of the modernist enterprise, was one. His installation, *The Repair from Occident to Extra-Occidental Cultures* (2012), was a highlight of that show and Kader recently expanded the research he developed for that work into the exhibition *Repair. In Five Acts*, which was on view at KW Institute for Contemporary Art in Berlin in August 2013.

Issa Samb, another artist I chose, actively worked on the deconstruction of Léopold Senghor's aesthetics of Negritude, which seemed to promote a reductive and fetishized idea of African symbols, of decoration and beauty. His work appears in sculptural form in the courtyard of his atelier on Rue de Jules Ferry in Dakar. Composed of found and transformed objects and materials—threads, fabrics, clothing, branches, stones, and other ephemera—it was reinstalled around a tree in the Aue Park in Kassel. A total artwork.

Samb founded Laboratoire Agit'Art in 1974 in Dakar. It is one of the most eclectic artist collectives known to contemporary art in Africa, with an iconoclastic practice mixing all fields of the creative process as the founding principle. As Samb likes to repeat, anyone engaged with questioning the prevalent order is a member of Agit'Art. Members of Agit'Art understood their practice as a counterweight that brought intellectual and artistic diversity into a homogeneous art environment.

/ Koyo Kouoh

Issa Samb, *Out of Balance*, 2012.
Documenta 13, 2012. Photos: Nils Klinger

CT: Documenta functioned as a Eurocentric art event with the notice-
able shift of Harald Szeemann's Documenta 5 of 1972.

KK: The real shift away from Eurocentricity started with Jan Hoet's
Documenta 9 in 1992. Hoet put "blacks on top," as he once said at a
conference where he talked about his "revolutionary" act of inviting non-
Euro-Americans. It continued with a greater curatorial awareness with
Catherine David's Documenta X, in 1997, and reached a point of no
return with Okwui Enwezor's Documenta 11, in 2002. It is, however, still
shocking in retrospect that it took until 1992 for European curators to
understand that the world is larger than America and Europe and that art
is practiced everywhere.

CT: And today everyone is curious about what's happening in Africa
and other developing regions.

KK: Well, what can I say? Africa has been an attraction for Euro-Americans
for over 600 years. In light of this, the small movements and occasional
peaks on the mainstream art world's radar are not relevant from my point
of view. What is important is the long-term professional and institutional
transformations that such curiosity will bring on both sides of the table.

CT: At the CIMAM Conference in Istanbul in 2012, you said that the
exhibition *Magiciens de la terre*, which was held in 1989 at the Centre
Georges Pompidou and the Parc de la Villette, highlighted a curatorial
crisis of contemporary African art. Can you explain?

KK: *Magiciens de la terre* took place a couple of years before the launch,
in 1991, of *Revue noire*, a magazine out of Paris devoted to contemporary
African art. *Revue noire* was followed three years later by the arrival of
Nka: Journal of Contemporary African Art, initiated by Okwui Enwezor and
Olu Oguibe in New York. We were in a context of major post–Berlin Wall
political and territorial shifts that transformed the understanding and per-
ception of the world in a radically new global outlook. Yet again Africa was
still heavily defined by others, especially in the realm of artistic practice.
The curatorial perspective and the selection criteria of that exhibition
showed how dangerous it is to let someone else build your house.

CT: How, in your view, did *Magiciens* reflect the way that non-Africans
have always spoken for Africans?

KK: *Magiciens* exposed a critical void of contemporary artistic practice by
Africans—though most African critics and curators who emerged after
Magiciens eagerly distanced themselves for various personal and ideologi-
cal positioning. It is, however, undeniable that the fraught curatorial and
theoretical premises of that exhibition prompted a few to take corrective
actions.

Magiciens was like a slap in the face to young Okwui, to young Simon,
to young Olu, et al. These curators were already in a becoming stage and
that event crystallized many things—for one, a curatorial crisis within

knowledge production on contemporary art from Africa, and a curatorial crisis of Africans around the reading and presentation of contemporary artistic practice. It also crystallized a national crisis in terms of the engagement of governments to promote arts and culture. The Dak'Art Biennial started in 1992, just three years after *Magiciens*! It represented a turning point in the exhibition of contemporary African art.

CT: Was Dak'Art a statement of the existence of art in the contempo-
rary mode and outside the tribal?

KK: Somewhat, yes. You know stigmas and stereotypes are tenacious. Up to today there are still people who believe that there cannot be contempo-rary art from Africa, implying that anything tagged as "contemporary" is a mere copy of Western artistic traditions. This suggests that the only valid art from Africa is classical and sculptural. Dak'Art proved different and triggered many professional aspirations.

CT: And for you?

KK: First of all, after 20 years of practice I still haven't settled in with the title of "curator" even though I use it by default. I stumbled into curatorial practice by necessity and I somehow still consider myself at best a sort of outsider and at worst an intruder. Beyond that I see myself as post-post-*Magiciens*; I'm professionally younger than that generation of curators but I'm conscious that I am working today because they paved the way and I am thankful. They are the first wave of savvy and critical art professionals who energetically shook the trees of the global comfort zones. I'm part of the second wave, and we now have a third and fourth wave, those who are curating Dak'Art this year, and this is super thrilling.

CT: In 2009 you worked with the architect David Adjaye on a very sig-
nificant exhibition that celebrated 50 years of African independence.
Can you tell me about that?

KK: I co-curated *GEO-graphics, A Map of Art Practices in Africa, Past and Present*, with Anne-Marie Bouttiaux, Nana Oforiatta-Ayim, and David as the artistic director. He had been invited by the Palais des Beaux-Arts in Brussels to mark 50 years of independence for 17 African countries. The exhibition was to take place at the Royal Museum for Central Africa (it is also called the Africa Museum), which was orginally built to display the collection of artifacts amassed by King Leopold II from the so-called Congo Free State. The show was required to present classical African art along with contemporary and cultural-historical research.
This was a huge challenge. Please understand, to make this celebration inside one of the harshest of the colonialist countries was exhilarating but at the same time quite puzzling as to how to celebrate five decades of independence in Brussels. And it took place at the moment when I was growing wary of making exhibitions in the conventional sense.

CT: Why?

KK: I wanted to change things! I wanted to change the conditions of how contemporary African art is shown, and at the same time I'm skeptical about any one exhibition being effective in that way.

CT: Very challenging indeed. Who supported the project?

KK: The Palais des Beaux-Arts and the European Union.

CT: Needing absolution, perhaps?

KK: Maybe there was that element. But I did not care about it. It was a welcome opportunity to do an exhibition in the context of 50 years of independence in contrast to the myopia of the celebrations that were staged in Africa. I didn't want a show as usual, meaning a show with a list of artists—I was more interested in how the last 50 years challenged the status quo in terms of artistic and cultural production in Africa, which is something that also sparked my personal growth.

And you could say that my reading of independent art spaces as a tool for transformation in society begins here. Instead of inviting artists to this show, I invited six art spaces: Didier Schaub and Marilyn Doula-Bell's Doual'Art in Douala; L'appartement 22 of Abdellah Karroum in Rabat; DARB 1718 by Moataz Nasr in Cairo; Bisi Silva's CCA, Lagos; Nairobi Arts Trust by Jimmy Ogonga; Prof. Yacouba Konate's La Rotonde des Arts in Abidjan; and of course my own RAW Material Company. Each one became a container holding other containers. Each space was totally free to do any presentation it desired: artworks, a library, or a discussion series. I continued the investigation of the role of independent spaces in changing the artistic landscape in Africa with "Condition Report: Symposium on Building Art Institutions in Africa," which took place in Dakar in January 2012, followed by an eponymous publication in 2013.

CT: This surely sparked your future work...

KK: It did indeed. After a few years of a nomadic, mobile existence, RAW established a physical space in 2011.

CT: You have said: "I have grown beyond the idea of Africa as a geo-graphical region, and rather, treat it as a mindset to give it a mental space that can be inhabited by anyone interested in the idea of Africa."[1] Would you reiterate that today?

KK: When I say I've grown beyond the idea of Africa as a geographical region, it's an invitation to expand the idea of territory to what it is, was, and could be.

1. Http://ocula.com/magazine/ conversations/koyo-kuouh, accessed Sept. 15, 2015.

It is also an invitation to de-nationalize or de-continental-ize this belonging, so to speak.

At RAW Material Company, we usually use the term "Africa-related prac-tices" because it's an invitation that goes beyond Africa for Africa's sake. People talk about globalization, the global village, specifically in the art world, but racism and exclusion are still at play. (If you look at the leading art fairs, for example, how many African galleries are accepted?)

Jim Chuchu, *Pagans IV* and *Pagans V*, 2013. Photographs. *Precarious Imaging: Visibility and Media Surrounding African Queerness*, RAW Material Company. Courtesy Mariane Ibrahim Gallery

Andrew Esiebo, *Untitled (Who We Are series)*, 2010. Photograph. *Precarious Imaging: Visibility and Media Surrounding African Queerness*, RAW Material Company. Courtesy the artist

/ Koyo Kouoh

CT: But doesn't that speak to why 1:54, as an African art fair, was formed?

KK: Yes, you're right, and I think that this is also a way of blossoming into a larger community, so that people begin to know this gallery and that gallery, be exposed to works and practices that they would not be otherwise.

CT: We began this conversation about 1:54, and we're now coming around to talking about it in terms of the larger picture, i.e., of how acceptance occurs.

KK: There is never acceptance! It's like the word itself. You're never given the word; you must take it.

Going back to this notion of growing beyond Africa, it's also an act of generosity. I think in terms of togetherness, of communality, of collaboration. RAW Material Company stands for artistic entrepreneurship, and for togetherness.

CT: Nabokov said that the government of Russia's czars, Nicholas I and II, "remained aware that anything outstanding and original in the way of creative thought was a jarring note and a stride toward revolution."[2] Your current exhibition installed at RAW Material Company, *Precarious Imaging: Visibility and Media Surrounding African Queerness*, features work by Zanele Muholi, Andrew Esiebo, and Jim Chuchu. Wouldn't you say this show is jarring or revolutionary to the community?

2. Vladimir Nabokov, "Lecture on Russian Writers, Censors, and Readers," in Nabokov, *Lectures on Russian Literature*, ed. and with an introduction by Fredson Bowers (San Diego: Harcourt, 1981), pp. 13–14.

KK: Well, I'm not as much talking about sexuality or gender as I am talking about the right to be free, basically.

CT: In many places this concept could be considered revolutionary.

KK: I just think that a free society develops better because a free person has more strength to be an active agent of society. It's no one's business what kind of sexual orientation people have as long it does not involve minors, nor that it manifests itself under constraint or violence. My year-long program about personal liberty is to counter certain lies, such as the persistent one that homosexuality is not African, as if sexuality has geographic or cultural delimitations.

CT: Your show at RAW Material Company is running simultaneously with the Dak'Art Biennial, and as such it is getting a lot of visibility. How is it being received?

KK: The show has had an overwhelming resonance locally and internationally. This is one of our most media-successful shows—everyone wants to report on it. But I think it's just zeroing in on the sensationalism of a hot topic. It is thus important to re-center the whole program and focus on the long-term investigation that began one and a half years ago and will continue for another year with more exhibitions and a final publication.

<u>CT:</u> In Dakar, is homosexuality punishable?

<u>KK:</u> Yes, with sentences that range from three months to five years in prison.

<u>CT:</u> And has anyone tried to shut down the exhibition?

<u>KK:</u> No. That's the advantage of Senegal. Senegal is very open when it comes to freedom of expression. Senegalese have a very strong democratic tradition and people have fought battles exactly to have this! We had apprehensions when we were planning the program that it might be dangerous, but since it's set in an artistic framework, the show was not considered threatening.

Postscript: The exhibition at RAW Material Company, *Precarious Imaging: Visibility and Media Surrounding African Queerness*, was vandalized on May 13, 2014, three days after I interviewed Ms. Kouoh. "The RAW Material Company was forced to interrupt the exhibition due to continuous pressure and acts of violence from the religious community and particularly from the Islamic NGO Jamra," E-flux e-mail newsletter sent on June 10, 2014, at 6:00 PM; Subject: Support Koyo Kouoh and the RAW Material Company. —C.T.

Carolee Thea: You have taken the name WHW (What, How & for Whom) for your curatorial collective, and for the purposes of this interview you prefer to speak as one entity.[1] What was the original impetus in forming your collective?

WHW: We started WHW in 1999. It was after the Croatian War of Independence (1991–95), when isolation, nationalism, and xenophobia reverberated in all layers of Croatian society. We four were studying art history and literature at the university. We first met when the publishing house Arkzin invited us to organize an exhibition dedicated to the 150th anniversary edition of the Communist Manifesto.[2] The show, titled *What, How & for Whom?*, brought us together as a collective.

CT: Were each of you curators at the time?

WHW: We were a mix of curators, critics, translators, or journalists living in a city where the art circle is small and the people who are involved in art through different channels know about each other's work.

CT: Why, in Croatia, was this exhibition so important?

WHW: Since 1990, the year after fall of the Berlin Wall, it was as if history had started anew; a zero year when everything connected to socialism was suppressed, creating an amnesia about the country and people's lives. When we dealt with the Communist Manifesto we felt no need to thematize or address it directly. Instead, *What, How & for Whom?* represented the three basic questions—What are we doing? How are we doing it? And for Whom?—that are proposed of every economic organization. They are a part of all economic theories. Furthermore, we researched the Communist Manifesto and realized that most of Marx and Engels's analysis of the nature of capitalism is still valid today, and so we shifted most of our research in that direction.

These three questions are viable ones in almost all segments of life, not only in terms of capitalism but culture and production as well, and we kept this as a form of inspiration. The exhibition took the notion of economic specificity—the relationship between the art and economics—as a point of departure for exploring a wide range of social subjects.

CT: What about the question of the audience and the relationship between the subject, production, and the audience?

WHW: The relationship with the audience does not always entail creating an interactive work, but creating an exhibition that will challenge people's perception without resorting to shock techniques. Making them think about a situation in the world is key.

CT: Yes, but isn't that contained in the artist's poetics? That is, if it is to be successful, it should convey ideas and feelings... otherwise, isn't it just propaganda?

1. WHW (What, How & for Whom) is a curatorial collective made up of four women from Zagreb, Croatia: Ivet Ćurlin, Ana Dević, Nataša Ilić, Dejan Kršić, and Sabina Sabolović.
2. Arkzin began in 1991 as the journal of the Croatian Antiwar Campaign and later became a publishing house. WHW notes, "It was virtually the only forum for critical voices who, during the war and the whole of the '90s, criticized nationalism and other related issues. It connected us to rare sources for contemporary theory, translation, and pop culture." Arkzin's 150th anniversary edition of the Communist Manifesto was edited by Boris Buden and featured an introduction by Slavoj Žižek.

Frankly, I had mixed feelings about the exhibition—I both loved and hated it. At first I found it preachy and monochromatic... dominated by black and white and red, initially with protest posters and afterwards, the senses. After my first go-around, I admit that I became open to other levels and discovered many amazing artworks. But how can you, as curators, get past this amalgamation of similar message or content, as if it were posted in a biased newspaper, like propaganda?

WHW: The daily news contains information cut and censored in a way that's defining it. But I'm pleased that you found the show propagandistic—it is what we tried to do. We did have another ambition, and that was to create tension between a propagandistic curatorial framework and a classical white cube... as in a museum exhibition.

CT: What was the point of that?

WHW: Exhibitions for us are a public forum where things can be discussed, where the audience can be involved but without the catchphrase of relational aesthetics.

CT: How does that apply to the way you curated the 2009 Istanbul Biennial?

WHW: An exhibition is a place to articulate discourses, a place that influences perception but may also politicize it. In that particular context in Istanbul, we thought that the Biennial, the museum, or the exhibition space could have a more educational component than other shows we or others have done in Munich or Berlin. Both public and private institutions continue to do the typical or traditional job of making an exhibition, the way they've done it since the '30s. And today, while there is an interesting art scene here in Istanbul, institutions for contemporary art are limited.

/ WHW

(pages 72–73 and above)
Etcetera (Loreto Garin Guzman and Federico Zukerfeld), *Errorist Kabaret*, 2009. Participatory installation. 11th Istanbul Biennial, 2009. Courtesy IKSV Istanbul Biennial/Etcetera Archive

We wanted, as an experiment, to present the Biennial as a classical museum exhibition, hoping that this could produce something interesting for the audience and for us. We also wanted to create a tension between the conventions of a museum display, the conventions of a biennial, and a propagandistic framework.

Additionally, our aspiration was to give the works the autonomy that they might have otherwise been deprived of through the propagandistic curatorial framework. We hoped that art would prevail and exceed our expectations. Hoping that the works not "be about" something, but be the works they are, their artistic procedures and concerns, which are not necessarily important for the theme of the exhibition, were interesting for us, given the role of authoritarian curators that we play.

CT: But you chose...

WHW: Of course we both chose and displayed the works in an attempt to establish a dialogue that would foster certain meanings, and, yes, we were quite authoritarian in that sense, but still we tried to give each work space to speak on its own so that the works could be smarter than us.

CT: That is interesting. I frequently talk with curators about standing behind the theme, and not just choosing the art to illustrate it.

WHW: Artistic autonomy is important for us, but you know, art is too often instrumentalized by politics. Our starting position is that this cherished autonomy is also an ideological construction that we want to challenge by proposing another ideological construction.

Frankly, we don't believe that the art shown regularly in mainstream institutions and exhibitions is autonomous; it is actually in the service of the market and wealth. We also believe it is in the service of political instrumentalization, as politics is in the service of profit.

Further, we believe that the entire notion of art should be clarified, shifting from a conception of autonomy to the tension between propaganda and autonomy. We tried to play with this and do not propose the answer; this was an experiment for us.

CT: Tell me about *Unemployed Employees – I found you a new job!* (2009).

WHW: It's a collaborative work by Aydan Murtezaoğlu and Bülent Şangar dealing with issues of the increasing inability of young people in Turkey to find meaningful work. University graduates are employed to do what are apparently meaningless actions: folding and unfolding shirts or offering samples of cheap perfume in a department store.

The artists created a blog in which they open up the discussion with visitors and problematize their own situation and that of young people who are facing similar obstacles, such as the precarious conditions of unionization and social protections, and the lack of stable or secure work. In a certain way the piece is an attempt by Aydan and Bülent, who are among the

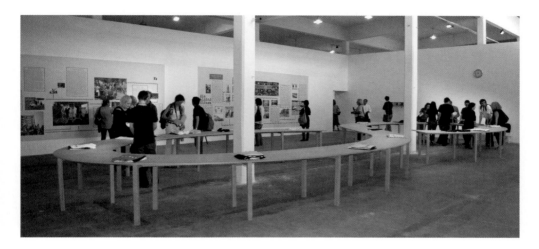

strongest artists in Turkey, to put their entire practice in the context of labor relations, and to problematize the question of culture in the process.

CT: In another venue of the Biennial, the Feriköy Greek School, you seem to have shifted to the more personal and poetic: the Israeli film-maker/artist Avi Mograbi's video *Z32* (2008) is one of the most fantastic works in the show. He brings to the fore the suppressed background of systemic violence and the individual means of its execution, asking what are personal and what are collective consequences. Appearing in his own film, he questions the ambivalence of his position and ethical involvement while he sings (as the commentator) with a small orchestra in his living room. Digital masks cover the faces of the two main protagonists, the soldier and his girlfriend. Another video, a trilogy called *Beyond Guilt* (2003–5) by Ruti Sela and Maayan Amir, also shown in the Greek School, addresses the undermining of the power relations between photographer and photographed, men and women, the public domain and the private sphere, object and subject. The film's directors, Sela and Amir, take an active part in the occurrence, seducing the interviewees and then turning the camera over to them as part of the aforesaid undermining of power relations between photographer and subject.

Aydan Murtezaoğlu and Bülent Şangar,
Unemployed Employees – I found you a new job!, 2009. 11th Istanbul Biennial,
2009. Private collection

The choice of the shooting locations, a pick-up bar or a hotel room, strives to represent an underworld with language and signifiers. The quick encounter before the camera calls to mind the ephemeral nature of intimate relations, but most of all the works allude to occupied territories, to terror, and to the army as constitutors of an Israeli identity, even in the most private moments. The sexual identity and the military-political identity seem inseparably intertwined. (The work shows a male nude lounging on a bed like David's Madame Récamier, discussing his feelings and the horrors of his experience as a soldier/terrorist. While the videographers are dealing with the psychology of the soldier, they are also employing their female gaze.) Do you want to talk about the gender aspect in your show?

/ WHW

Avi Mograbi, *Z32*, 2008. Video. 11th
Istanbul Biennial, 2009. Director of
photography: Philippe Bellaiche

Ruti Sela and Mayaan Amir, *Beyond
Guilt*, 2003–5. Video. 11th Istanbul
Biennial, 2009. Courtesy the artists

WHW: We're a female collective and wanted female voices addressing the very topical issues of gender; historical positions are present here, too, opening up the site to very important questions. For example, the issue of normality, or proposed normality, in everyday life, as explored in the work of KwieKulik, a Polish couple [Zofia Kulik and Przemyslaw Kwiek]. In the Greek School they presented their interpretation of a project that the two of them started in 1972, just a few days after their son was born, and continued until 1974. At that time they were using their home as both a kind of artistic studio and a workplace. In it they organized a number of independent art events, exhibitions, and projects. They weren't a part of ZPAP, the official art system; they were in their home, working and living.[3] And in that sense this piece can be interpreted as a very radical way of merging those two notions of life and art.

3. Związek Polskich Artystów Plastyków (Association of Polish Artists and Designers).

It was important for us to insist on women's issues and to include a representative number of women in the show. It was also important to choose works that problematize the position of women; to make no mistakes on that issue and to make it very visible. And it was significant for us to offer other ways of viewing art. Our perspective was also displayed in how we connected/positioned each of the pieces in order to create a dialogue between them. The critic and writer Stephen Wright used the metaphor of an open labyrinth to discuss our position as cultural workers, and our position inside/outside as symbolic.[4]

4. Http://www.e-flux.com/announcements/curated-by-what-how-for-whom-whw, accessed Aug. 27, 2015.

The artist Sanja Iveković produced a kind of a virus throughout the sites connected with the Biennial, with red fliers strewn on the floor, each stating the position of women in Turkey. The papers were on the one hand dismissed as garbage, but on the other they were an important element insisting that this issue should be disseminated.

CT: Actually, I believe you curated the show through a myopically propagandistic lens.

/ WHW

KwieKulik, *Activities with Dobromierz*, 1972–74. Color slides. 11th Istanbul Biennial, 2009. Courtesy the artists

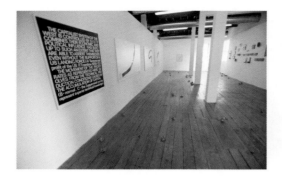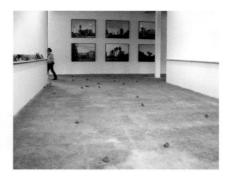

<u>WHW:</u> You're right. After 1989, communism, because it had failed com-
pletely in its realization, became something not to forget or suppress.
Milton Friedman and the Chicago School of Economics dreamed that the
market will regulate all the needs of human society. But this is a complete
illusion just as communism was—an ideological construct. We, in a way,
attempted to problematize this issue for our exhibition. In that respect I
think we're not saying anything new.

 <u>CT:</u> How does Sharon Hayes's work fit into the concept of your show?
<u>WHW:</u> Her work is about gender politics and the idea of public demonstration;
it is also about how politics are culturally translated. Sharon always
adjusts the message to specific contexts. Here in Istanbul she radically
shifts the notions of private and collective politics through the language of
love, spoken in a public space. When we are talking about Istanbul, it's
quite important to speak of the challenges posed by hetero-normativity, in
that this society has an even more painful cultural bias in favor of opposite-
sex relationships and against same-sex relationships than some other
places in the world.

 <u>CT:</u> Why did you use Brecht and *The Threepenny Opera* as a pedestal?
<u>WHW:</u> It has been one of the traits of our work to use teaching tools and
personae, those that might seem larger than life and overwhelming. We
first apply them and then dismiss them (in a way). We needed a kind of
starting point and Brecht became our mediation, communication, and
canon. Basically it was the theme song, "What Keeps Mankind Alive?"
It's about silence, oppression, acquiescence, doublespeak, and hunger—
all of which continue to surround us. We needed to return to that song,
to look at it with sober eyes 80 years after it was written and see what
resonates today.

 <u>CT:</u> I'm curious about the materials employed by the artists in the show.
 It was amusing to see so many pieces made of cardboard and only
 a few videos....
<u>WHW:</u> The notion of the materials that artists are using in their works
is very interesting because it brings us back to the three questions,

/ WHW

Sanja Iveković, *Turkish Report 09*,
2009. Text printed on red paper.
11th Istanbul Biennial, 2009. Photos:
Sanja Iveković

What? How? And, For Whom? The question *how* is connected to the choice of material the artist uses. Mladen Stilinović, a Croatian artist who started to work in the mid-'70s, is a very good example. He has always claimed that in his works he wants to use materials that offer a poor character, not discarded or found materials, but the kind of artistic process that can be done without any kind of institutional support. Maybe in that sense his work is about a search for a more autonomous means of artistic production.

Many of the works in the show, such as Sanja's red fliers, were presented in "underground" conditions using basic materials. When you're addressing the issue of food shortages or oppression, we believe it would be obscene to use super-technological material/language to express those ideas.

Sharon Hayes, *I didn't know I loved you*, 2009. Single-screen video installation, color, and sound, 10 min. 11th Istanbul Biennial, 2009. Courtesy the artist and Tanya Leighton, Berlin

/ **WHW**

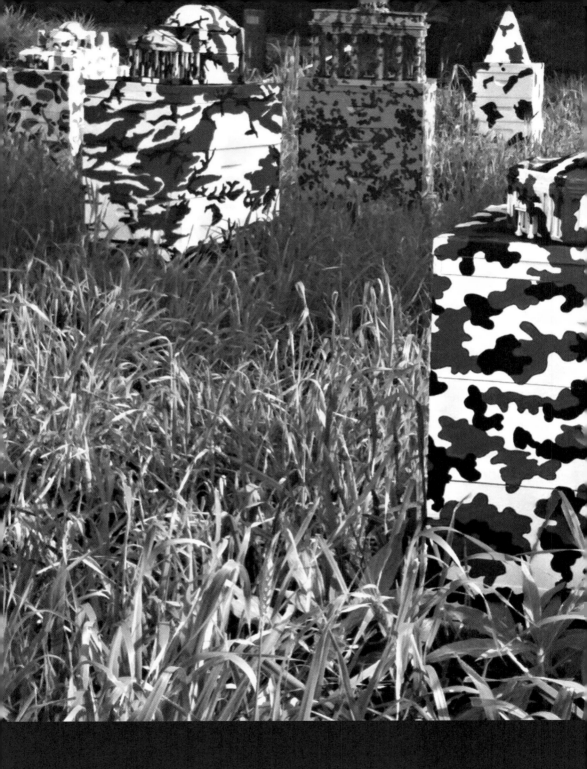

/ **David Elliott**
Interview 2011

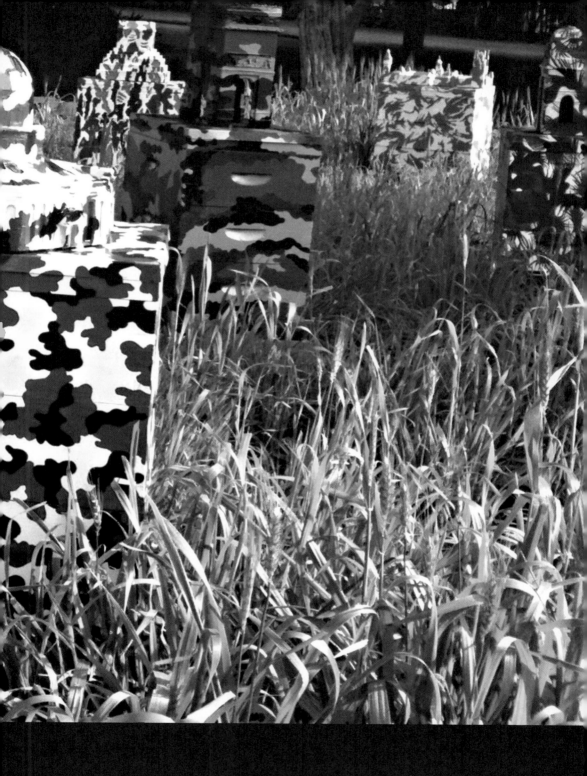

Fiona Hall, *The Barbarians at the Gate*, 2010.
Wooden beehives, wood and metal architectural
models, plastic action dolls, paint, and wallpaper.
17th Sydney Biennale, 2010. Courtesy the artist
and Roslyn Oxley9 Gallery, Sydney

<u>Carolee Thea:</u> You're a cultural historian and curator focusing on the visual cultures of Central and Eastern Europe, Russia, and the non-Western world. In your pioneering exhibitions you've integrated non-Western art with contemporary art. How did your interest in art and curating come about?

<u>David Elliott:</u> I was 19 years old, studying history at the University of Durham. Before this I seriously believed I would become a theater director, but a spell working in a theater cured me of this idea and I decided to go to university! In 1968 Ian Barker, a close friend at university, had curated a multimedia Surrealist festival with access to paintings and objects from the Edward James collection. I was astonished by this and started to think along similar lines. I was concerned, as were many at this time, by what appeared to be a resurgence of dictatorship and fascism, and I began to think about how this could be counteracted by the insistent, soft power of art.

With this as a propellant, at the age of 21 I made my first series of exhibitions, *Germany in Ferment: Art and Society in Germany 1900–1933*, which took about 18 months to set up. It included two works by Erich Heckel and Emil Nolde that I had first seen many years earlier, and it examined the relationship between German art and society in the period leading up to the Nazi takeover. The main exhibition featured paintings, drawings, prints, and sculpture, with subsidiary shows and programs presenting photography, design, posters, film, theater (Frank Wedekind's *Spring Awakening*), and music.[1]

This show, which opened in Durham in 1970 and traveled to the City Art Galleries in Sheffield and Leicester, started a particular line of inquiry in my work that came together again in 1995 at the Hayward Gallery in London, where I was a lead curator on a large exhibition for the Council of Europe, *Art and Power: Europe under the Dictators 1933–1945*, which subsequently traveled to Barcelona and Berlin. It focused on the battle of ideas, ideologies, and styles in art and architecture in Germany, the Soviet Union, Spain, and Italy during the 1930s and '40s by setting "degenerate" or unofficial art against the official art sponsored by the State.

1. *Spring Awakening (Frühlings Erwachen)* is the German dramatist Frank Wedekind's first major play and a seminal work written sometime between autumn 1890 and spring 1891, but performed only in 1906, when it premiered at the Deutsches Theater in Berlin under the direction of Max Reinhardt. It carries the subtitle *A Children's Tragedy* and criticizes the sexually oppressive culture of *fin de siècle* Germany, offering a vivid dramatization of the erotic fantasies that it breeds.

The forms and conflicts within art have changed a lot since that time but many of the issues are still alive. Although it has been inevitably compromised, I strongly believe that the idea of artistic autonomy, so vital in the early years of the twentieth century, is still a driving force in contemporary art and aesthetics. It enables artists to create better and more challenging work than they would otherwise. It is also a crucial paradigm for other, basic human freedoms that are nearly always under threat.

/ <u>David Elliott</u>

CT: Today, for both indoor and outdoor exhibitions, it's important to involve the spectator in the space. In 2005, at the 9th Istanbul Biennial, which was titled *Istanbul,* the curators, Vasif Kortun and Charles Esche, created a platform in which the entire city interacted with the artworks. Artists chose not only the dramatic antique sites but also created projects in and among living and working environments. You would either come upon them as a denizen of the city or search them out as a visitor. The successful parts were the pathways through the city and seeing art integrated into different places throughout the community.

DE: Yes, they were making a political decision by organizing the exhibition in this way as well as making a kind of homage to Jan Hoet's 1986 exhibition, *Chambres d'amis,* which was shown in Ghent. I share their suspicion of spectacular venues, which tend to overshadow art, but, in the right place, I don't mind showing spectacular art that holds its own. I also care about audience and aim to attract as wide and diverse a public as possible, but we are starting to talk about two different models of exhibition. The first, as followed by Kortun and Esche, is the path of "discovery," which involves a certain amount of difficulty in locating the work. The other is the opposite of this, which minimizes difficulties of access while focusing on the complexities of the works themselves. I mainly prefer the latter, and feel that the problem with the other model is that it turns art into an instrument for other purposes. The intersection of contemporary art with the city is difficult to control, and it can give the impression of "trying to do good" in poor neighborhoods, in a rather middle-class way.
When you're working as a curator, exhibitions are incremental, made on top of and in counterpoint to other exhibitions. Occasionally they're produced in reaction to other shows you've seen, but the whole process is an organic mixture of different kinds of creativity. For example, my exhibition *Bye, Bye Kitty!!! Between Heaven and Hell in Contemporary Japanese Art*, held at the Japan Society in New York City in 2011, was conceived as a corrective to the dumb, reductive Western view of contemporary Japanese art that regards it as little more than sex-obsessed infantilism. I wanted to show how many contemporary Japanese artists were engaged with their own society, as well as deeply self-critical. Half of them happened to be women.

CT: You curated the 17th Biennale of Sydney (2010), *THE BEAUTY OF DISTANCE: Songs of Survival in a Precarious Age*. Was your theme inspired by artists, artworks, or Sydney itself? And how much of it followed an intellectual framework around the past and/or contemporary civilization?

DE: Well, that show was made for both Sydney and for myself. It was

/ **David Elliott**

formulated for the Biennale, but it was also related to two other large exhibitions that reflected a particular place and time, as well as the condition of art as I saw it. One was *Wounds: Between Democracy and Redemption in Contemporary Art,* curated by myself and Pier Luigi Tazzi, which opened the new building of the Moderna Museet, Stockholm, in 1998. The second show, the inaugural of the Mori Art Museum in Tokyo in 2003–4, titled *Happiness: A Survival Guide for Art and Life,* looked at the East and West. It examined different traditions and ideas of culture in "East" and "West" over a much longer historical span, from fifth-century China to the world today, mixing works of different media and origins so that contemporary art by figures such as Robert Ryman and Bill Viola could be seen in the context of, and measured against, what had gone before. The show also looked at art through the prism of four different ideas of happiness: arcadia (or utopia), nirvana, desire, and harmony, which reflected ideas relating to politics/ideology, spirituality/metaphysics, appetite/consumption, and forbearance/compromise.

The Biennale of Sydney reflected on the history of the city in particular and colonization in general, and on definitions of contemporary art, especially in relation to such "excluded" practices as the art of First Peoples and folk art. It took as its starting point the necessity of aesthetic and critical distance in art, and how this is reflected in terms of physical or geographical distance.

CT: What were your key ideas?

DE: There were several. The first was to acknowledge the foundation of modern Australia in its penal and industrial past. Cockatoo Island, one of the main venues, was formerly a high-security jail and derelict shipyard. It's now a decaying heritage site that had been off-limits to the public for more than 100 years, but it became a venue for large-scale sculptural installations. It's the world's first urban waterfront campground, home to a conference center and businesses and holiday accommodations—a place to escape the everyday, a canvas for creative types and cultural events. The different buildings, ranging from institutional, with ghostly solitary cells, to industrial to domestic, provided a perfect array of highly charged spaces that were perfect for contemporary art. I invited a number of artists to create works there.

Another idea was to put forward a model of contemporary art as a kind of level playing field. "Contemporary" means now; the term confers no other value. What is more important is whether the works in question are any "good." I wanted to include Western and "non-Western" art with folk art and the art of First Peoples as part of the conversation about what was good.

CT: What criteria do you use to decide what is "good"?

DE: Certainly not market value! We're living in a world of multiple cultural and aesthetic systems. And if you are going to make value judgments, you need to be aware of the similarities and differences among the systems, so that you can make up your own mind within some kind of context. Although

many Aboriginal communities are relatively isolated, they cannot avoid being part of the contemporary world and have many points of contact with the outside. They choose what they want to keep and discard and, as with Chinese brush painting or different styles of "Western" oil painting, there are both continuities and ruptures in their art, tradition, and culture. If you're a critic or a curator, anything can jump out at you from the trees, but at the end of the day what you have is instinct. And, well, there are also value judgments—craft and art; architectural drawings and art—but since the 1990s most of these barriers have begun to slough off. A sense of what is beautiful is an important part of this process. I mean beauty in both a positive sense and its opposite, "terrible beauty." I believe that this is a word really worth keeping hold of as long as it's flexible.

> CT: As artforms have multiplied and morphed exponentially, term-inology has had to become more flexible. Thus, what is or is not beauty is also relevant to its form—particularly in terms of the digital revolution, the contemporary art of postcolonial countries, and the multitude of diasporas.

DE: Finally you're going to be looking at art; therefore you're bringing a whole series of values to it. What makes something art or not art is aesthetics. You can't avoid it.

> CT: Going back to the underpinnings of the Sydney show, I understand that you were inspired by, among other things, folk music.

DE: Yes. Since I was a kid I've been interested in folk music and I used to sing sometimes in pubs and clubs. Many years ago, at the New Museum in New York City, Marcia Tucker invited me to dinner. At one point, to my delight, all the other guests started singing. These weren't really folk songs, more nineteenth-century church music: "white spirituals." It was a hilarious evening. Later, through Fred Tomaselli, I rediscovered the artist Harry Smith and how he bridged the avant-garde art and filmmaking with ethnography and collecting folk music, some of which he reissued in the famous 1952 boxed set of LPs, *Anthology of American Folk Music*. Smith didn't want barriers between these activities, and I like that. (Many classical composers, of course, have also repossessed folk tunes, as well as popular songs from their own or other cultures.)

> CT: Globalization has brought together cultural or pop ideas derived from the other that often function as a multicultural virus. For example, in her 2004 video work *COSplayers*, Chinese artist Cao Fei borrowed from the cosplay subculture from Japan.

DE: For my Sydney show I included things from the outside alongside things from the mainstream program. It was about not mixing, but keeping them distinct, respecting their distance.

> CT: Speaking of outside and inside, what was your overall opinion of the 1989 exhibition *Magiciens de la terre*?

DE: In the context of Paris at the end of the 1980s it was a brave and

/ **David Elliott**

important show, but even at the time I was doubtful about its "magical" framework. This seemed to be a classic art-world ploy, in which exoticism took on the mantle of the much vaunted "new spirit" of the early 1980s. Many of the works were unfamiliar and really strong in their own right, and did not need the imprimatur of magic or of established Western names to make them worth looking at. The whole reference to magic harkened back to colonial attitudes of otherness.

> CT: The title of this Biennale, *THE BEAUTY OF DISTANCE: Songs of Survival in a Precarious Age,* seems poetically similar to *Magiciens de la terre.* Do you agree?

DE: For me the idea of "songs" went back to folk music, a genre that has almost disappeared. Louis Armstrong said, "All music is folk music. I ain't never heard a horse sing a song."[2] I found this wonderfully direct, and if you can agree with that, then all art is folk art. This is what the exhibition was about.

2. Louis Armstrong, quoted in *The New York Times,* July 7, 1971, p. 41.

> CT: Let's look at some of the artworks in your Sydney Biennale. In the largest space, the Museum of Contemporary Art, there was one huge piece made up of poles.

DE: Yes, the largest space of the museum housed 110 vertical *larrakitj,* or memorial poles, which were made between 1998 and 2009 by 41 Yolngu Aboriginal artists from northeast Arnhem Land, in Australia. Originally these works were rooted in funeral ritual: the dead were left on a platform in a tree to be picked at by birds until only the bones remained. The bones were then cleaned and stored in poles made from hollowed-out tree trunks, on which different clan marks were painted that related to the deceased.

After the colonists converted everyone to Christianity, this kind of burial ritual died out and the poles, with different conceptual landscapes, cosmologies, and signs painted on them, are now made purely as art. In these particular works, the artists have undergone a series of transitions and developments generated mainly through the aesthetic languages that they themselves have developed—a range of styles that have no relation to Western tradition. The quality, dynamism, and creativity of this work just blew me away.

> CT: Were you also inspired by the theory of the clash of civilizations, the speed of information, or the implications of the current political climate?

DE: One can't avoid the social and political contexts of our times and, of course, I have a position as a writer, curator, and critic that, because it is articulated, is inevitably political. I am deeply skeptical about the whole idea of a contemporary "clash of civilizations" as what we share and need as human beings is far greater than any difference—also, since 1945, the advanced weaponry at our disposal is too powerful to deploy without invoking disaster on an unprecedented scale.

/ **David Elliott**

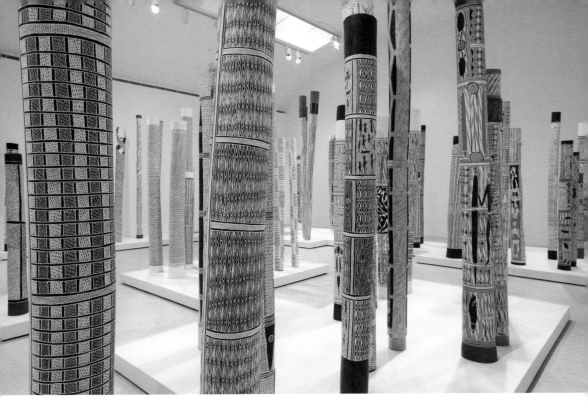

But it's important to understand the different meanings of "political." Unlike many I have no external agenda or ideology other than an underlying belief in the necessity of quality and creativity in art as an articulation of quality in life. Sometimes this means being extremely critical of things as they are, but at a remove from life through means that are primarily aesthetic. In this sense every choice a curator makes is political. Exhibitions are series of propositions, arguments, and dreams, all played out in the public sphere.

CT: Another major piece in the show was the installation *Inopportune: Stage One* (2004) by Cai Guo-Qiang.

DE: I have worked with Cai since my first two exhibitions of new art from China in Oxford. This work is made up of nine cars suspended, turning over in space, with a syncopated system of LED lights "exploding" in sequence. It has a mesmerizingly stroboscopic effect, like watching a car crash or a huge explosion. In its grisly beauty the work refers to terrorism and the precarious age in which we live, a theme that ran through this exhibition in many different ways. Cai wrote about his fascination with the incandescent beauty of the terrorist act as well as his incomprehension about why someone should sacrifice his or her own life for such a cause.

CT: You've been working with him since 1993. Some curators are loyal

Installation of 110 *larrakitj* (1998–2009) made by 41 Yolngu artists from northeast Arnhem Land. Earth pigments on hollowed string bark logs. 17th Sydney Biennale, 2010. Courtesy Kerry Stokes Collection, Perth. Photo: Jenni Carter

/ **David Elliott**

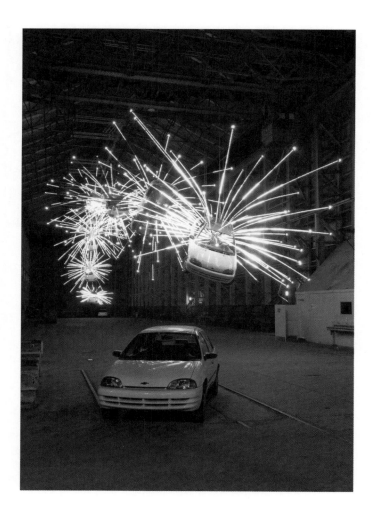

to artists with whom they've collaborated over a period of time. Is that also true with you?

DE: It's not so much a matter of loyalty. I like working with certain artists because I respect their work greatly, so obviously they're people I return to, like Louise Bourgeois, who for many years was one of the great neglected figures of the twentieth century, rather like Yayoi Kusama. This was largely because they are women and, at that time, of the wrong generation.

CT: Another piece I found amazingly poetic was Mark Wallinger's helium balloon video.

DE: Yes, *Hymn* (1997). It's a wonderfully self-reflexive work. He's standing alone on a stool in a London park, a cylinder of helium gas by his side,

/ David Elliott

Cai Guo-Qiang, *Inopportune: Stage One*, 2004. Nine cars and sequenced multichannel light tubes. 17th Sydney Biennale, 2010. Courtesy 17th Sydney Biennale and Seattle Art Museum, Gift of Robert M. Arnold, in honor of the 75th Anniversary of the Seattle Art Museum. Photo: Sebastian Kriete

Paul McCarthy, *Ship Adrift, Ship of Fools*, 2009. Rigid urethane foam, steel, wood, and carpet. 17th Sydney Biennale, 2010. Photo: Sebastian Kriete

with a picture of himself as a 10-year-old boy with a floating balloon teth-
ered in his hand. Periodically he takes a shot of the gas and starts to sing
"There's a Land for Little Children," a cloyingly sentimental Victorian
hymn, in a squeaky high-pitched voice. People were both amused and
freaked out by it. It's a strange, haunting reflection on both childhood and
the passing of time.

But to come back to your point about "conflicts of civilization," the
European power base that developed in the eighteenth century (of which
Australia and the U.S. are part) is over. Today we're entering another
world in which power is distributed differently. I am not implying that the
West is finished but it's no longer calling the shots and can no longer claim
the moral high ground in the shameless way it tried to do before.
Throughout the world there is a moral discussion quite separate from what
the politicians or the power brokers are doing. The eighteenth-century
Enlightenment ideals of autonomy and human rights started in Europe in
this way and then spread virally. This process has not yet finished; politi-
cians have often tried to stop or appropriate it for their own ends, but
these ideas are now being tested and hopefully strengthened by mixing
with the ethical traditions of other cultures.

 CT: Obviously the world is in a different place today than it was even
 10 years ago. Many nations are evolving out of colonialist pasts,
 reevaluating their own politics—not only in terms of political persua-
 sion but also religion and clan affiliations, economic realities, and
 international cooperation.

DE: You know, in a Guignol-like way, Paul McCarthy's large sculpture *Ship
Adrift, Ship of Fools* (2009), which had its first showing at the Biennale,
refers to the pride and stupidity of vainglorious adventurers, to the excess-
es of consumer society, to pirates, cowboys, gangsters, cavalrymen—even
to some artists. In this work he captures the folly and corruption of our
times, its complacent sense of entitlement, its self-absorption and greed.

 CT: The Sydney Biennale also encompassed ecological consider-
 ations. Janet Laurence's *Waiting – A Medicinal Garden for Ailing*

Plants was a tentlike structure inside of which visitors glimpsed a kind of metaphysical laboratory designed to breathe new life into sick flora. Korean artist Choi Jeong-Hwa used hydraulics to create the illusion that a giant flower was inflating and deflating with each breath.

DE: Yes, this was one of a number of site-specific works made for the show. Jeong-Hwa's was a simple, acid pink inflatable floating on the main pond of the Royal Botanic Gardens, powered by a fan and a motor as well as by the wind. He also made a large installation out of green plastic sieves in the "cleavage" of the sails of the Sydney Opera House. Situated not far away was Fiona Hall's installation, *The Barbarians at the Gate*, a

work consisting of groups of functioning beehives that compounded ecology with paranoia and racism. The tops of the beehives were carved into the shapes of iconic buildings from various parts of the world, while the outsides were painted in the military camouflage patterns of the countries in which each "building" is situated. This single, large flowerbed therefore became a microcosm of world conflict, with "action man" soldiers rappelling down the branches of an overhanging tree.

The bees were intended to be non-Australian, which unlike the indigenous variety actually sting, but this was not permitted by the customs officials, so the "barbarians" really did remain outside the gate. This was an elegant and sardonic work that reflected the insecurities of foreign policy and social divisions within Australia as well as those much farther afield.

CT: Social networking seems to be infiltrating the political climate as well as the art world. Is this digital turn apparent in any of the works included in your exhibition?

DE: Obviously, social networks have become increasingly influential, and an underlying theme of the Biennale of Sydney was the fact that different cultures often reflect upon each other in unpredictable ways. The fundamental changes in the perception of time and space wrought by the digital revolution were echoed in the question of "distance" in the show's title, and how this relates to how one views art. In response to this I worked with SuperDeluxe, one of Tokyo's leading alternative spaces for experimental music, culture, and ideas, to create a Biennial hub, club, and performance area in Artspace, one of the other venues of the exhibition. We also commissioned a grand opera for Cockatoo Island called *Cockatoo Prison* from the British punk cabaret group the Tiger Lillies. It contained many new songs about the worst crimes one could ever imagine, and it was a sellout every night.

/ **David Elliott**

Choi Jeong-Hwa, *Breathing Flower*,
2010. Fabric and air blower. 17th
Sydney Biennale, 2010

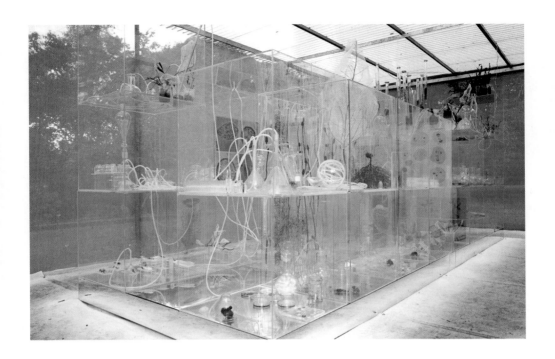

CT: How do you envision future biennials?
DE: A lot of people go around and say there's too many of them but for me the biennial is just another big exhibition of contemporary art. The one I did in Sydney was the third in a series of other shows I had made, and not all of them were biennials. The main point in all of them, though, was to create a discussion about different ideas of what could be "good" in art. But by definition a biennial happens every two years and this temporal, repetitive element makes me think that a biennial should concentrate on the recent past and not be a kind of history lesson as there are other platforms for that kind of exhibition. In any event, art, if it is any good, embodies the past with a different slant and it should also reflect on where it takes place. Not that it should be provincial, but it needs to work with the space and the country where it's located, and the curator needs to know about or research this. Contemporary art is inevitably rooted in the past and provides a platform for the future—from this it derives its unique character. The role of the biennial is to capture and articulate this intelligently, taking into account, but not blindly following, the particular perspectives of each place.

Janet Laurence, *Waiting – A Medicinal Garden for Ailing Plants*, 2010. Australian native plants, laboratory glass, blown glass, steel, horticultural mesh, acrylic, salt, amethyst, medical silicon tubing, water and various other fluids, ink jet prints and screen prints on acrylic, water crystals, tulle, carbon, sulfur, various plant seeds, charred wood and plants, water pumps, ash. 17th Sydney Biennale, 2010. © Janet Laurence. Photo: Jamie North

/ **David Elliott**

Carolee Thea: The six of you—all female curators from Asia—were invited to participate in the 9th Gwangju Biennale, to be held in Korea in 2012. You each pursued individually initiated themes: Logging In and Out of Collectivity [Nancy Adajania, India]; Re-visiting History [Wassan Al-Khudhairi, Iraq]; Transient Encounters [Mami Kataoka, Japan]; Belonging and Anonymity [Sunjung Kim, Korea]; Individual Spirit in Identifying Alternative Logics and Horizons of Connectivity [Carol Yinghua Lu, China]; and Impact of Mobility on Space and Time [Alia Swastika, Indonesia]. Collectively you decided to call the exhibition ROUNDTABLE. How did you come to choose this title?

Mami Kataoka: First of all, this was not meant to be an exhibition with one single viewpoint, and the title reflects this. In 2006 Kim Hong Hee was the director of the Gwangju Biennale; it was the only time a woman owned that role, and she was Korean. With the current Biennale I believe the invitation to invite women from other Asian countries was a structural issue. The insistence on having multiple curators was to reflect the many views of society today and to create an interesting dialogue.

CT: How did you arrive at a topic?

MK: It took 10 months to devise something in common or consistent among us. It had started to feel hopeless.

Wassan Al-Khudhairi: First we fleshed out the themes and began to think about artists who could really help negotiate this dialogue, open up the discussion. We made PowerPoint presentations, showing images and lists of artists.

MK: You build up a whole discussion, but the last person may not agree. So it was quite impossible to come to a consensus on one theme.

WA-K: Around the table some people said, "Oh, I think that's a really strong piece," or "You should look at a piece they did 10 years ago," or "Let's have that, or pick a new piece," or "Did you think about so-and-so artist?" So, even though we all started with an initial list, that list changed and evolved through our discussions with one another.

MK: At some point we realized how much time we spent at the table talking and on our last day in Qatar, with everyone about to leave on different flights to different cities, the pressure was great and we realized that we needed to agree on something. While sitting at a round table in a Chinese restaurant, Carol Yinghua Lu spontaneously said, "How about the idea of 'roundtable'?" Some thought the idea sounded too political, but then we all came to like it. During the conversation everyone crystallized their ideas and themes and we began to find interesting connections.

Sunjung Kim: I was thoroughly inspired by the youth and energy of the five other curators. I've worked in this field for many years and had begun to lose my passion for curating. I saw myself in them and remembered how it felt to be a young curator.

(pages 94–95)
Do Ho Suh, Rubbing/Loving Project: Gwangju Catholic University Lifelong Institute, 2012. Colored pencil (cyan, magenta, yellow, black) on paper, wooden structure, video monitor and player, single-channel video projection with audio, speaker, and light-bulb electrical element. 9th Gwangju Biennale, 2012. © Do Ho Suh; courtesy Lehmann Maupin Gallery, New York and Hong Kong

/ Adajania, Al-Khudhairi, Kataoka

<u>CT:</u> In the last century, and maybe even now in the American South, women sat around a table working communally to create a quilt. It is almost as if there's a female logic to this kind of grouping.

<u>MK:</u> One day while I was in Australia, I was looking at an amazing collection of paintings by Aboriginal women and found a huge square one done by eight or ten women; it was a beautiful painting with patterns close to the edge; it seemed to have been created by individuals sitting around a table. They chose as their topic the energy of the land and the streams and the currents of the water and wind. Indeed, this was a collective production and it was of no importance who made each part.

<u>Nancy Adajania:</u> For me the *ROUNDTABLE* is first, foremost and inescapably a political gesture. The will to political change is inscribed in the birth moment of the Gwangju Biennale, the May 1980 Gwangju people's uprising against the dictatorship. But, over the years, this revolutionary moment, which ignited the Korean civic imagination, has been fetishized into a ceremonial homage. My response to the question of how to reanimate and make this birth moment relevant was to fold a large retrospective of South Korean photographer-activist Noh Suntag into the 9th Gwangju Biennale. For one of his series he rephotographed the decaying funerary portraits of the victims of the uprising, stained by earth, grass, rain, and dew in the cemetery. These photographs were accompanied by an image showing journalists and politicians descending on the cemetery for a photo-op on the anniversary of the uprising.

<u>Carolee Thea:</u> How did your own histories contribute to the show?

<u>Sunjung Kim:</u> The civil uprising in 1980 is actually the inspiration for the Gwangju Biennale. After the May 18 democratic uprising Gwangju sought regeneration through artistic or cultural endeavors. Unlike other cities that would have claimed factories or other means of industrial development for redemption, the city and citizens of Gwangju wanted to launch a cultural event. Hence the Gwangju Biennale was begun. The military killed so many citizens here. I know the history and everybody in Korea knows this history. I'm from Korea. Foreign curators, such as Okwui Enwezor and Massimiliano Gioni, though they knew of this civil uprising, did not share my more emotional approach to it.

Do Ho Suh's *Rubbing/Loving Project* (2012) is about the uprising, but he expresses the event in a different way. He worked with a group of Gwangju students and young artists to take paper rubbings at the Daein Market, at the former Gwangju Catholic University dormitory, and at a room in an old house in downtown Gwangju. They collected traces or scribblings left by individuals in abandoned spaces, revealing the forgotten stories of the nameless people who lived through this time. Initially I wanted to use

/ **Kim, Lu, Swastika**

the Korean C.I.A., a national security center in Gwangju, for this portion of the show. It's a huge abandoned space, but the military said no. In a way the piece was actually coming from Do Ho Suh's experience: He was in high school in 1980, and at that time under the military government, newspapers had blank spots. His act of tracing involves reading through layers of censorship to recover memories that had disappeared, through marks made by those who have since become anonymous.

Many others in my section, such as the Korean artist Kyuchul Ahn, dealt with the uprising indirectly. His series *Where They Left* incorporated Gwangju as a stage where he instigated interactions with the people of the city: a painting depicting waves, which was divided into 200 pieces, and the fragments of four shattered sculptural objects were dispersed throughout the city. The artist took ads listing the missing artworks in the local newspaper and asked people to bring back the pieces. Some fragments were returned, many with added graffiti, but most became part of the city, floating in the stories and imaginations and memories of the people. Each piece is a metaphor for the city's regrets and desires.

Nancy Adajania: To your question about how our histories contributed to the show, I would say that I tend to resist all forms of interpellation. While I have included strong works by women artists from Asia, Eastern Europe, and the Arab world in the exhibition, I did not wish to be circumscribed by the boundaries of geography or gender. Such essentialist thinking can be soul-depleting. Instead I come to this debate from a transcultural position. I relate keenly to Sarat Maharaj's concept of "entanglements," which could be read as a braiding together of transcultural histories of confluence and conflict, revolutions and complicities. For example, I created here a transcultural intersection among the works of three artists who are partisans of their various political causes but find their partisanship breaking down under critical reappraisal: Sheba Chhachhi's annotated photographs of the Indian women's movement; Noh Suntag's photographs on the "state of emergency" in South Korean society; and Fouad Elkoury's video slideshow on the Palestinian cause. Elkoury's melancholic photographs of the Palestinian leader Yasser Arafat escaping from Beirut in the 1980s, on a ship called the *Atlantis*, are rare archival documents which were restored for this Biennale.

Kyuchul Ahn, *Where They Left*, 2012.
Acrylic on canvas, terra cotta, and plaster.
9th Gwangju Biennale, 2012

Wassan Al-Khudhairi: I was at Mathaf [Arab Museum of Modern Art, Doha, Qatar] for five years, and my last exhibition there was on Cai Guo-Qiang. I was already beginning to think about how to position works, asking questions such as, "How can we think about the Arab world within an Asian context?" So for me, it was about looking eastward, rather than always looking westward.

And this is where Carol and I really connected. We were able to have a lot of conversations about the Biennale, but also separate from it, and about the similarities and differences in the way art has developed in China in relation to the Arab world, both commercially and in terms of scholarship and a sort of amnesia about the Modern.

CT: When you say "amnesia about the Modern," what do you mean?

WA-K: There's a feeling or sense that there wasn't any art in the Arab world until the commercial world evolved. And I think there's some similarity in the way that happened in China in the '90s.

I also think that in the visual arts, there's a lack of scholarship about Modernism in the Arab world, and this was a pivotal agenda for me when I was at Mathaf: how to create more opportunities to develop scholarship and a platform for more dialogue about the development of Modern art in the Arab world. So I wanted to work with artists who were already, in one way or another, engaged with the idea of revisiting history.

The Algerian artist Fayçal Baghriche is one such artist. His film *The Message Project* (2010) is based on *The Message* (1977), which is by a Syrian-American film producer and director, Moustapha Akkad, and starred Anthony Quinn and Irene Papas. Akkad was born in 1930 in Aleppo, Syria,

Fayçal Baghriche, *The Message Project*, 2010. Video. 9th Gwangju Biennale, 2012. Courtesy the artist and Taymour Grahne Gallery, New York

/ Kim, Lu, Swastika

and was best known for producing the original series of *Halloween* films and directing *The Message* and *Lion of the Desert*. He was killed along with his daughter, Rima Al Akkad Monla, in 2005 in Amman, Jordan, by a suicide bomber.

Akkad made *The Message*, which recounts the origins of Islam, in English and in Arabic, with two different casts, shot scene by scene, back to back. In *The Message Project*, Baghriche interweaves these two versions to create one film in which a sort of democratic platform exists and the two languages can engage through the retelling of the story of the Prophet. (Of course, you never see the Prophet, because he can't be visualized.) If you watch closely, you'll notice that the characters will be speaking English and then all of the sudden you'll be reading subtitles, but the editing is so close, frame to frame, that you almost can't catch it.

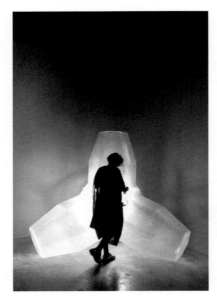

Sophia Al-Maria's work, *Scout*, is a sculpture that adopts the shape of a twentieth-century animé spaceship at a scale that recalls relics from lost civilizations. It is based on the concrete breakers used in the late 1970s and early '80s along the coast of Qatar to prevent the land from eroding. Sophia was inspired by the shape of these breakers, and they're reproduced in fiberglass. She says that they represent "the ultimate object of denial, a temporary solution to the inevitable approach of the future and the irrevocable loss of the past." She's imagining a future history for the Gulf, using the sculpture as a symbol to think about how the water is rising so quickly, here and in other lands and places.

The two-person collective Pages comprises Nasrin Tabatabai and Babak Afrassiabi, who are from Iran but are based in the Netherlands. Their installation traces the making of an unfinished film called *The Persian Story*. Produced in 1951 by BP, it was originally meant to be a feature-length film about Iran and its oil refineries, but it was left unfinished because of the political situation at the time, when the oil industry was nationalized and the refinery was closed. The artists visited the BP archive, now in London, and re-present the story here. Included in the exhibition you'll find the archived letters between the producers and the company, where you can learn the original intention of the film and follow the events that ensued, such as the various constraints on access and bringing in equipment, along with their politics.

/ Adajania, Al-Khudhairi, Kataoka

Sophia Al-Maria, *Scout*, 2012. Fiberglass, resin, light, and sound. 9th Gwangju Biennale, 2012. Courtesy the artist and The Third Line

<u>Carol Yinghua Lu</u>: Many narratives of art practice in China evolve from the art-
ist's own reflections about viewing certain structures as models. But what I
try to understand in my country's own regional history is that there are
different causes of development that don't necessarily follow a logical pro-
gression. What I want to suggest is that artists should stop thinking about
certain global trends and instead search their personal or regional history
in order to find meaning or relevance in their practice. Many artists mistak-
enly don't delve into their own background and history, and instead emu-
late global trends.

 <u>CT</u>: Asia is vast, stretching from the Suez Canal to the Pacific Ocean;
 from the Caucasus Mountains to the more than 17,000 islands that
 comprise Indonesia. Asia and Europe form a continuous landmass,
 and the boundary between them is a historical and cultural construct
 whose definition has fluctuated throughout history. Asia also varies
 enormously across and within its regions with regard to ethnic
 groups, cultures, environments, economics, historical ties, and gov-
 ernment systems. Given all of this, the idea of inviting the six of you
 to jointly create a major art exhibition strikes me as highly ambitious.
 What did you learn from this experience?

<u>CYL</u>: For me the most valuable part of this collaboration and from co-curat-
ing this Biennale is that it reminds us of how little we know about each
other in Asia. We definitely know more about our colleagues in Europe and
North America. We have little knowledge about each other's practice and
so the process of being together, despite all the difficulties, opened up
possibilities for seeing colleagues who are close to us geographically, but
not necessarily in approach. (We have a lot to learn from and to under-
stand about each other).

My concept, Individual Spirit in Identifying Alternative Logics and Horizons
of Connectivity, is a continuation of my previous curatorial projects, spe-
cifically two shows, *Little Movements: Set Practice in Contemporary Art*

/ <u>**Kim, Lu, Swastika**</u>

Nasrin Tabatabai and Babak Afrassiabi
(Pages), *Seep*, 2012–13. Video 2, HD,
17:39 min. 9th Gwangju Biennale, 2012.
© Nasrin Tabatabai and Babak Afrassiabi

and *Accidental Message: Art Is Not a System, Not a Road*. Each examined subjectivity in individual art practice. Clearly I'm most interested in creative subjectivity as it's manifest in all forms, not only in visual art, as I said, but also in the work of philosophers, filmmakers, poets, and even politicians.

Li Fuchun's installation, *A Slice of Sky* (2012), reflects this idea of creative subjectivity. He drilled holes into the remains of fossilized human bones

and animal skeletons and used fishing line to suspend them from the ceiling, with fixed, fragmented mirrors throughout the room. Then a beam of red light, choreographed by Li, bounced off the mirrors as it traveled through the holes in the bones, and the viewer automatically became immersed in this imaginary space. I also exhibited the curatorial project of Boris Groys, himself an art critic, media theorist, and philosopher. His project *After History* was about the French diplomat, statesman, and philosopher Alexandre Kojève, who amassed a huge collection of 5,000 photographs and 6,000 postcards while traveling in Europe and Asia in the 1950s and '60s. Among Kojève's photographs are images of religious architecture in Russia that are devoid of human presence, and of

the natural landscape in Asia, which include people. Through this body of photographs, says Groys, Kojève articulated his belief in the dichotomy between an aesthetically harmonious East and a stifling yet hollow West. Kojève was frequently cited in Francis Fukuyama's *The End of History and the Last Man*, a book that discusses what happened after the end of the cold war with the evolution of three world blocs.

CT: Alia, the works you selected for this exhibition are characterized by social activism in addition to strong historical content. You've said that most artists in your country are involved with social action and/or protest.

Alia Swastika: In Indonesia we don't have an infrastructure to disseminate knowledge of contemporary art history, so everything is really do-it-yourself in terms of art and the cultural sector. There are two ways of being political in Indonesia. First comes engagement with political issues, especially during the 1980s, when artists really became part of political movements. Usually artists start political movements together with students. The middle class in Indonesia is not very political, nor critical, so it is artists and

/ Kim, Lu, Swastika

Li Fuchun, *A Slice of Sky*, 2012. 9th Gwangju Bienniale, 2012. Courtesy the artist

Boris Groys, *After History. Alexandre Kojève as a Photographer*, 2012. 9th Gwangju Biennale, 2012. Photos: Natalia Nikitin

students who usually form the social avant-garde. Secondly, there is the idea of being political in terms of building an art system and art infrastructure. Artists in Indonesia are always acting as activists in this sense. In fact you cannot be just an artist. An example of this is Tintin Wulia's piece, *Nous ne notons pas les fleurs, Fort Ruigenhoek,* which shows that the female artist can talk about the body beyond the framework of a so-called established sexuality.

 <u>CT:</u> How is globalization evinced in the work that you selected?
<u>AS:</u> The process of globalization blurs boundaries, a phenomenon that becomes paradoxical given that the idea of the nation-state remains tied to geographical territory and politics. In the long run globalization actually strengthens rules of boundaries. Hiromi Tango and Craig Walsh (working together) and Delaine Le Bas explore different aspects of globalization in their pieces.

Tango and Walsh's *Home* (2012) treats the idea of community as the abstract territory to which one returns. For four years the artists left behind their urban lives and toured small towns in Australia, engaging in dialogues with local people. This journey forced the artists to redefine the concept of home, a complex space containing a depth of meaning related to intimacy and privacy. On that basis they invited local communities to

/ Adajania, Al-Khudhairi, Kataoka

Tintin Wulia, *Nous ne notons pas les fleurs, Fort Ruigenhoek*, 2011. Game performance and installation with growing flowers, plant pots, saucers, surveillance camera, and monitors. 9th Gwangju Biennale, 2012. Courtesy the artist and Kaap/Stichting Storm

become involved in a project on the theme of home. They interviewed people about their memories of home, asking them to bring one nostalgic object with them. These interviews were videotaped. For the show these objects are grouped together to form a screen onto which the taped interviews are projected.

Le Bas's piece is about the constant nature of migration, the movement between territories and the departure from home. She is a London-based Romani artist who uses the visual language of Roma culture to place nomadic life at the root of humankind's civilization and cultural diversity. She created an installation using visual codes compiled as a collection of archival journeys about migration, combined with the violent reality of adulthood. Showing the human ability to overcome risks and fear, she employs shifting notions of bravery dealing with uncertain situations, as well as the risks of nomadic life.

Craig Walsh and Hiromi Tango, *Home*, 2012. Video projections, sound (stereo) assemblages. 9th Gwangju Biennale, 2012. Courtesy the artists. Photo: Craig Walsh

Delaine Le Bas, *Witch Hunt*, 2008 (ongoing), detail. 9th Gwangju Biennale, 2012. Courtesy the artist and Galerie Kai Dikhas, Berlin. Photo: Tara Darby

/ **Kim, Lu, Swastika**

I close my section of the show with a kinetic installation piece by Sara Nuytemans, *Observatory of the Self 3.1*, which included *Observatory of the Self 2.1* (both 2012). It explores the notion of observing oneself. In Nuytemans's meditation room, all you see in the whole space is yourself. The hanging mirrors evoke the solar system. With everything orbiting around you, you become the center of the universe. I enjoy the idea raised about the play between individuality and collectivity. There is a big mirror, so when you're turning around, you are circumnavigating the world—you're the one who adventures while the world remains still.

CT: Mami, given that Japan has recently experienced devastating environmental disasters, are there artists in the show whose work addresses environmental issues—perhaps from a collective point of view?

Mami Kataoka: Today in Japan there are demonstrations against reactivating nuclear power stations. After the Fukushima nuclear power plant incident in 2011, gradually all the nuclear power plants around Japan were closed for investigation and everyone was pleased. However, nuclear power plants bring business and jobs to nonindustrial or rural regions. Since the 1950s there had been a myth that nuclear power would bring happiness in the future, so nobody really questioned the issue. So you see it's quite difficult to solve some of these complex political, economic, and ethical problems.

There have always been oppositional views, but they were superseded by the government and the media, who were very good at promotion. Now, huge natural disasters, followed by this meltdown, have made people much more aware of the times we're living in. The artists of my generation never really participated in demonstrations because they were always hesitant to speak up about their political opinions. Today, however, every Friday in Tokyo many young people attend demonstrations surrounding the Parliament; they're committed to banning nuclear plants.

Carolee Thea: Four of you have combined your spaces but the other two, Nancy and Carol, have their own separate areas. How did you all decide upon the spatial design of the exhibition?

/ Adajania, Al-Khudhairi, Kataoka

(top and middle)
Sara Nuytemans, *Observatory of the Self 3.1*, 2012, exterior and interior. Stainless steel, mirrors, wood, motor, and rotan. 9th Gwangju Biennale, 2012. Courtesy the artist

(above)
Sara Nuytemans, *Observatory of the Self 2.1*, 2012. Stainless steel, mirrors, gears, 12V motor, power pack. 9th Gwangju Biennale, 2012. Courtesy the artist. Photo: Jhoeko

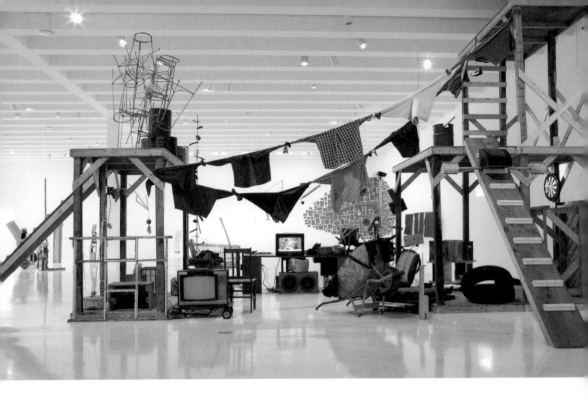

Mami Kataoka: In the early stages we had discussed possible themes for the show and one was about self-organization. This came from the artist Abraham Cruzvillegas's ideas about *autoconstrucción*, or "self-building," that is, with many manifestations. It's a concept he embodies in multimedia sculptural installations and performances about doing things yourself.

Wassan Al-Khudhairi: Many of the walls in the gallery were created for the 2011 Gwangju Design Biennale, and for the sake of conservation and funding we used those and added others. That way a lot of our production budget could go to the artists who were making new work, which was something that I was really interested in. This was great, especially for an emerging artist, who would be given an opportunity to produce a piece for which he or she otherwise wouldn't have the resources, the platform, or the opportunity.

Carol and Nancy were allotted their own spaces, as they wanted it that way. We wanted to create open dialogue between the two of them as well as the four of us. The roundtable ended up being the best framework: it provided flexibility and allowed us to reflect our own positions within the model. Carol and Nancy worked within their two arenas, and when it came to the spaces among the four of us, it was much more of a back-and-forth dialogue. We would talk about the artworks and begin placing and integrating them. The installation would change often until we finally arrived at the placement. You've got to start somewhere, so you just begin and keep evolving.

/ Kim, Lu, Swastika

Abraham Cruzvillegas, *The Autoconstrucción Suites*, 2013. Walker Art Center. Photo: Olga A. Ivanova for Walker Art Center

CT: There's harmony in some spaces, and in others there are transitions between spaces and ideas.

WA-K: Gallery 3 contains the concentration of Carol's works and Gallery 4 has the concentration of Nancy's. The transition between galleries always begins with a piece chosen by the other curators in the collective. So when you get to Gallery 3, there are several works by my artists, and an artist selected by Alia transitions into Nancy's theme in Gallery 4. So even within those spaces where individual curators have concentrations, we've tried to build up a kind of dialogue that leads from one theme to the next.

Nancy Adajania: Just to clarify, I did not begin with the idea that I wanted to have a separate exhibition within the larger exhibition. I was always interested in the spaces of entanglements between our positions. But as we conversed, I realized that our intellectual and political positions were extremely divergent, and neutralizing them into a homogenous whole would not be a truthful representation of our predicament.

I open my section with a Reading Table, which is an attempt at remapping biennial history from a Global South perspective. I inaugurate this journey by surprising the viewer with a photograph of a South-oriented map by the twelfth-century Andalusian geographer Al-Idrisi. He was commissioned by Roger II, the Norman king of Sicily, to produce a comprehensive map of the world and the largest atlas compendium. Al-Idrisi completed this work in 1154 and named it the Kitab al-Rujar, the Book of Roger, in his patron's honor. This collaboration across religious lines was a triumph of the

confluential culture of the twelfth-century Mediterranean, in which Muslims, Jews, and Christians engaged with one another to produce dazzling new forms. Al-Idrisi's map marks a completely different way of imagining the globe from the South. It continued Pharaonic Egypt's South-oriented geography and cosmology, and also emphasized the importance of the African and Indian Oceans contexts of Mediterranean trade, culture, and power.

Next to the map there is a historic photograph of Nehru, Nkrumah, Nasser, Sukarno, and Tito at the meeting of non-aligned nations at the Yugoslav delegation in New York, 1960. The Non-Aligned Movement (NAM) supported nation-states that were emerging from colonial domination to determine their own destiny: a "third way" that was a wager on

/ Adajania, Al-Khudhairi, Kataoka

From the Reading Table, 9th Gwangju Biennale, 2012:
Top: Photo of Jawaharlal Nehru, Kwame Nkrumah, Gamal Abdel Nasser, Sukarno, and Josip Broz Tito at the meeting of Non-Aligned nations at the Yugoslav delegation, N.Y., 1960, courtesy Wikipedia; photo of Mulk Raj Anand (left) at Triennale-India, courtesy Lalit Kala Akademi; Triennale-India award of honor, courtesy Lalit Kala Akademi
Above: Close-up of NAM photo

imagining the world during the cold war differently, both from the U.S.-driven or NATO perspective and the U.S.S.R.-driven perspective.

I followed this up with alternative histories of biennial-making: Triennale-India, 1968; Venice Biennale, 1974; Havana Biennial, 1989; and the first Gwangju Biennale, 1995. Next to the NAM photo is the image of Mulk Raj Anand, who pioneered the first Indian "perennial": Triennale-India, in New Delhi in 1968. Triennale-India emerged from Nehru's non-aligned philosophy as an alternative to the binaries of cold-war politics. It was a confident expression of globalism from the South. Although chronologically the Bienal de São Paulo (1951) is seen as the first biennial of the Global South, its early editions imitated the Venetian model, privileging Western avant-garde practices. While São Paulo was funded by the Rockefeller Foundation, Triennale-India was supported by the Indian state. For a Third World country to host an international exposition in the 1960s was a major gesture of self-assertion.

But even within its own country, Triennale-India is long-forgotten history. I inserted these three early biennials in order to explore multiple modernisms from a non-Euro-American perspective. This retrieval is a confidence-building gesture to see ourselves not as latecomers, guests, or gate-crashers but as pioneers, hosts, and catalysts in our own right.

CT: Were there certain methodologies employed in displaying the artworks you selected?

Sunjung Kim: I've seen all of the Gwangju exhibitions since 1995, and as a reference to past shows, I invited Michael Joo and Rirkrit Tiravanija. Michael is a Korean-American, and the Gwangju uprising, where the military killed many civilians, has had a strong effect on his work. Both Michael and Rirkrit were in the first Gwangju Biennale. When they revisited they talked about their first experience and how that inspired their thinking about a new work for this show.

I grew up with this Biennale, yet rather than repeat gestures I wanted to find another way to support small alternative art spaces in Asia. So I talked with Tobias Rehberger about designing a roped-off space at the entrance, where I proposed to install a shop. Tobias designed it and I collected 100 artworks from Cambodia, the Philippines, and Indonesia. We invited small art spaces in Asia to donate pieces, and we commissioned limited editions by older artists. We charged only for the shipping of sold works, and all the proceeds were given to the artists for their own art spaces.

People don't always understand the nature of what goes into display. Galleries 1 and 2 of this Biennale are actually recycled from the 2002 Gwangju Biennale, for which Yung Ho Chang, a Chinese-American architect, designed the space. Instead of spending a lot of money on new construction, I used the existing structure for the exhibition, as well as outside

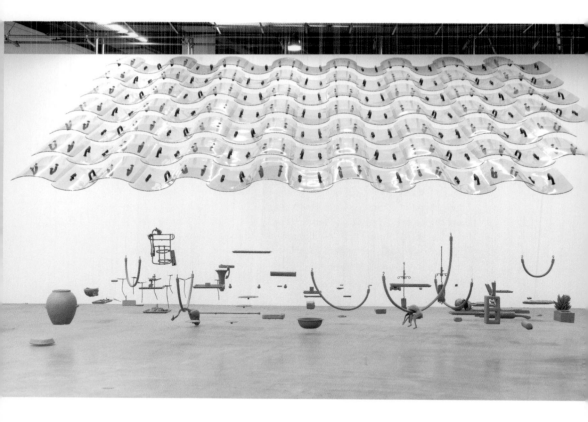

Michael Joo, *Indivisible*, 2012.
Polycarbonate riot shields,
plasticene, and stainless-steel
wire. 9th Gwangju Biennale, 2012.
Courtesy the artist and Kukje
Gallery, Seoul

Rirkrit Tiravanija, *Untitled 2008
(the future will be chrome) (ping
pong table)*, 2008. Mirror-finished
stainless steel. 9th Gwangju
Biennale, 2012

/ Adajania, Al-Khudhairi, Kataoka

Darinka Pop-Mitić, *On Solidarity*,
2005 (ongoing). Mixed media.
9th Gwangju Biennale, 2012

venues. The money I saved I was able to give to the artists for higher production costs.

NA: A site like a biennial gives us the freedom to produce not just information but also new knowledge. Moving faster than the academy and the museum, a biennial can capture and convey shifts of reading, interpretation, and relevance. It can serve as a probe into eclipsed histories and neglected scenes, whether across a country or within a subculture or discipline. For my section of the show, even as I was producing a provisional cartography of biennials from the Global South, I included a mention of a lesser-known edition of the Venice Biennale in my Reading Table. Rather than create binaries of the West versus the rest, I wanted to show how the Venetian hegemonic model of biennial-making has been a self-disruptive one as well, reconfiguring itself to respond to the various political crises in 1968 and 1974 where it showed solidarity with the Chilean cause of freedom. Carlo Ripa di Meana, the left-leaning president of the Venice Biennale, responding to the death of Chile's first socialist president, Salvador Allende, in 1973, and the rise of Augusto Pinochet's dictatorship, decided to devote the 1974 edition of the Biennale to Chile. Exhibitions, screenings, and conferences were organized under the theme Freedom to Chile. Chilean artists who had been forced into exile by Pinochet's dictatorship formed the Brigada Salvador Allende group and painted murals alongside local artists all over Venice.

Then, in 1977, some of the Chilean artists and revolutionaries in exile went to Yugoslavia, where they painted a mural outside the Belgrade School of Painting. This is where the Serbian artist Darinka Pop-Mitić, whom I invited to this Biennale, comes into the narrative. As a child she would often pass this mural, and she was haunted by its images. She refers to this experience in her own large, on-site mural for this Biennale—another example of

entangled transcultural histories. The 1977 mural was meant to express
the solidarity between the people of Yugoslavia and Latin America. Since
Yugoslavia had maintained a non-aligned position during the cold war, it
would often seek affinities with resistance movements in places like Chile.
But what does this reenactment of solidarity mean in a post-Yugoslavian
context against the backdrop of the violent polarization of the 1990s? What
happens when a utopia is lost or betrayed?

For this Biennale my intention was to represent artists through a body of
work, so that they wouldn't simply dissolve into the large exhibition. In
conversation with Maha Maamoun, I decided to show her videos as a tril-
ogy. *Domestic Tourism II* and *2026* were made before the Arab Spring.
Domestic Tourism II comprises footage from popular Egyptian cinema,
showing scenes shot against the pyramids of Giza that juxtapose the shift-
ing present against ancient history. *2026*, in the mode of science fiction,

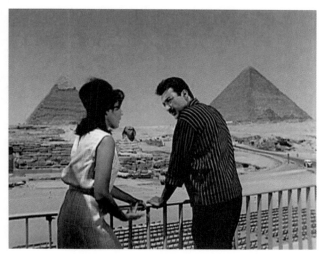

prognosticated the imminent revolution. The third film, *Night Visitor: The Night of Counting the Years*, was made during the revolution and turns its attention to the confrontation between state terror and the citizenry at large. Taken on the run by citizens storming the State security buildings in Cairo and Damanhur, these cellphone images are in a continuous condition of disintegration. The abstract register of *Night Visitor* reminds us that when a revolution happens, there is no single image that prevails, and language breaks down as a guide to future action. It is not easy to prophesy outcomes with clarity, or even to discuss differences on the way forward. What remains is an abstract image, a wager on the hope of utopia unrealized.

Carolee Thea: In my research I found that certain South American countries work collectively to boost their economic status on a continental and global scale. I wondered if that is also true of Asian countries? Is Pan-Asianism among the ideas you explore in this exhibition?

Carol Yinghua Lu: I see Pan-Asianism as a symptom of the anxiety of self-definition among practitioners in Asia. I believe the same kind of anxiety of self-definition is manifest in our colleagues in Europe and North America as well, but in very different forms. So to create this kind of Asian-ness, for me, is rather a sign of anxiety. It's about trying to understand where we stand in this globalized world today. The way I see it is that the more connected we become through globalization, the more anxious people feel about defining their own identity. This anxiety has intensified over the past years. I've also seen different manifestations of this. I would also say that the need to speak explicitly about Asia, as an idea, is a reflection of that anxiety.

Nancy Adajania: The focus on China, India, or Southeast Asia today owes more to the idea of the Asian Century, and is premised on a model of economic advancement, not on their cultural dynamics. I am, therefore, suspicious of present-day notions of Pan-Asianism, which are more about opportunism than about seeking affinities. The idea that Asians will speak in one voice is a fallacy.

I have described the phenomenon of the Silk Route and its adjunct cultures as "globalism before globalization." I am certainly interested in the history and potentialities of the Silk Route, where goods, arts, ideas, and narratives came together. These were stages for cultural encounter and experimentation, with far-reaching consequences for Buddhism, Christianity, Hinduism, and eventually Islam, as well as the societies in which these religions flourished. We need to develop a more comprehensive understanding of the Silk Route legacy, and not see it only in terms of artifacts. It is a way of thinking about entanglements that can lead us out of a limited understanding of Asian-ness being little more than a brand.

/ Kim, Lu, Swastika

Maha Maamoun, *Night Visitor: The Night of Counting the Years*, 2011. Video. 9th Gwangju Biennale, 2012. Courtesy the artist

Maha Maamoun, *Domestic Tourism II*, 2009. Video. 9th Gwangju Biennale, 2012. Courtesy the artist

Mami Kataoka: I can't escape being Japanese; I can't escape having been born in 1965. Compared with the other younger curators here like Nancy, Carol, or Wassan, this is important. I've gone through society in a different time and space, and so I carry a different historical perspective. These differences generate dialogues. For me it's interesting how different people from different societies and different ages look at the current changes within society and try to find a point of adjusting.

CT: I suppose this informed your decision to include the work of an older artist like Allan Kaprow. He was, of course, an artist whose anti-art and audience-participation works contributed to radical changes in the course that art making took during the twentieth century.

MK: Yes, in his work, in which Happenings are a sort of performative practice, environment is about one's relationship with the space or installation, about perceiving the space around you. My subtheme for the show, Transient Encounters, deals with how objects relate to the surrounding environment and how we feel about or perceive the space in between: the negative space and those invisible ties that connect us to the rest of the universe, which is connected with ancient Asian cosmology. I was actually more interested in how different elements could be connected with invisible forces, and how we could have an important balance or equilibrium. Kaprow's *Push and Pull*, in which viewers are invited to rearrange objects in a room, demonstrates this.

CT: Another piece that you chose is *Lessons of Revolution*, made by the Kyrgyz couple Gulnara Kasmalieva and Muratbek Djumaliev in collaboration with the ArtEast School for Contemporary Art in Bishkek. They created a wonderful schoolroom that is a relational environment, filled with children's desks, and on the desks are laptops with images of protest movements. There's also a ballot box made of plexiglass; it has no slot, where one would cast one's ballot, and it is filled with ashes.

Gulnara and Muratbek are trying to teach younger generations how they too can change society. Kyrgyzstan is a small country and, compared to Kazakhstan, which is a vast land with vast natural resources, it has been through very difficult times over the last 20 years. The shift of the country's political and social system from socialist and communist toward democratic was crucial. It's now a place where you'll actually come across people who believe that art can change society. They believe in the power of art.

There was a time when some of the Asian countries were looking at the West via Japan, yet basically they were making efforts at nation-building in the postwar, postcolonial era.

MK: Yes. We did not look at each other because there was an imbalance in terms of power, development, and politics among us. Today these countries

Allan Kaprow, *Push and Pull: A Furniture
Comedy for Hans Hofmann*, 1963/2014.
Environment. Reinvention by Mami
Kataoka, 9th Gwangju Biennale, 2012.
Courtesy Allan Kaprow Estate and
Hauser & Wirth

/ Kim, Lu, Swastika

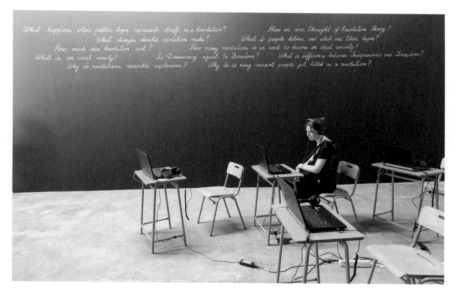

Gulnara Kasmalieva, Muratbek Djumaliev and
ArtEast School for Contemporary Art, Bishkek,
Lessons of Revolution, 2005–12. Video, object,
photo and book archive, interactive installation.
9th Gwangju Biennale, 2012. Artistic collective
from the ArtEast School for Contemporary Art:
Bermet Borubaeva, Nikolaj Cherkasov, Nellya
Dzhamanbaeva, Oksana Kapishnikova, Anatolij
Kolesnikov, Samat Mambetshaev, Aytegin
Muratbek Uulu, Meka Muratova, Dmitrij Perovskij,
Diana Ukhina

have begun to have more economic power and confidence. So it is impor-
tant that Asia be understood as a region where diverse political and
economic development and histories—and interrelated cultural histories—
are bundled together. Now, finally, in each nation we are learning about
ourselves. Within the massive amount of information available online, you
ultimately have to go back to yourself, where you are, and where you're
starting from, time-wise and space-wise, and not only in reference to
Western art history or Western philosophy. Asia is changing so rapidly,
you become sort of unstable about where you are, and although some
things remain unchanged, you have to find more stable ground.
In the case of migrations, people don't really change—even if you migrate
to the United States, you don't become totally American. We all carry
historical, cultural, and customary behaviors, and so these migrants bring
their culture along, and that is what interests me more. It's about how
people carry their history with them, and even if they move or change their
geographical positions, they always inherit or bring their cultures along.
No matter the reason for migration, political or economic, it's difficult to
rid yourself of the more sensory and bodily relationship with your roots.
Individuals adapt themselves toward the larger shift—the change or muta-
tion of society, political or otherwise. I'm interested in how society or
individuals try to keep the balance. So if society goes toward one extreme,
there's always this strong force to bring it back. And when you go to one
extreme state of mind, there's always a counter-force to bring you back.

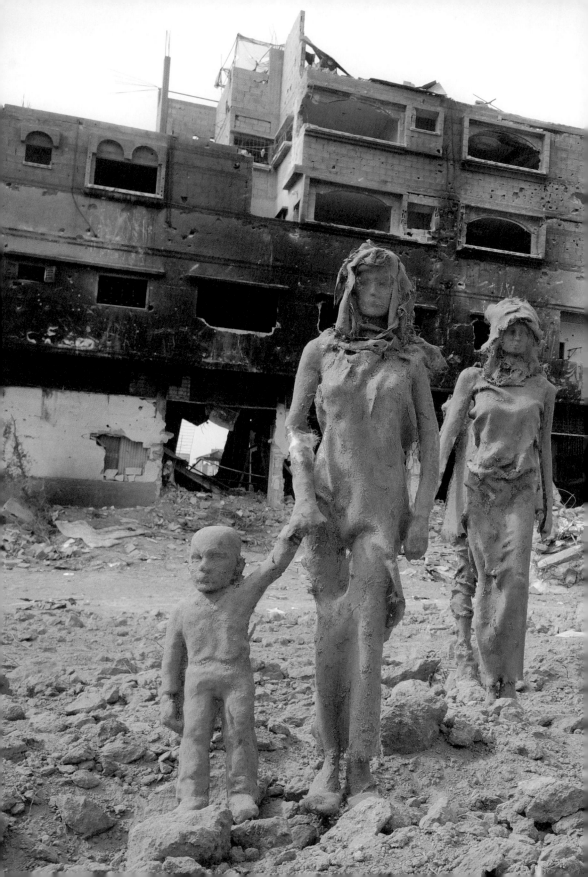

Carolee Thea: You began your career with the Anadiel Gallery in East Jerusalem, then the Al-Ma'mal Foundation for Contemporary Art in Jerusalem, followed by XEIN Productions and other important and seemingly impossible projects. How did your history, growing up in East Jerusalem, inform your work as an art professional?

Jack Persekian: Where we lived didn't have much access to art, be it museums or exhibitions or even art books or magazines. But I was one of the lucky few who had this exposure because my father was the main bookbinder in the city. In his workshop I came across books and magazines from different libraries around Jerusalem and beyond. So I had the privilege of access to this visual information, which gave me a cultural perspective—not only within Palestine and Jerusalem, but internationally as well. As I was growing up I understood the impact this has on a community, on general aesthetics and the way we deal with productions and presentations. And with time I understood the relationship between that and the state of siege that had been imposed on us. I began to see how, through my work, I could gradually break that isolation and connect with the outside world to raise the level of exposure that gradually came with the projects of the gallery and the foundation.

CT: Where did you attend university?

JP: In Bethlehem. There I read and worked on my English. Apart from other pursuits I was very interested in the language.

CT: Let's go to the idea for the first Qalandiya International Biennial, which took place in 2012 across a number of cities, including Ramallah and Gaza. What was your motivation to curate such an ambitious exhibition?

JP: Well again, if you followed my logic, the first edition was an attempt to break that isolation and bring in knowledge and education in the field of visual culture; everything else falls within a long-term strategy. Staging a biennial is a very old dream. I initially thought it would require tons of money as well as the support of governments, but after working on the Sharjah Biennial for seven years, I learned how to adapt and to bring modalities from the international art scene to the situation here. Creating exposure, bringing in people from other parts of the world, providing resources and a platform for the local art scene and local artists are all part of the undertaking that eventually culminated in the Qalandiya International Biennial.

CT: Where does the name Qalandiya come from?

JP: It's the name of an infamous checkpoint that basically splits the West Bank in half. It's the daily ordeal for people—for Palestinians, of course—trying to cross from one side to the other. Qalandiya is also a place that is rich in history: a village north of Jerusalem where the first airport was established, a place where you would connect with the world. However, in our generation it became a place of hardship,

/ Jack Persekian

(pages 118–19)
Iyad Sabbah, *Worn Out*, 2014.
Clay sculpture. Courtesy the artist

Wafa Hourani, *Qalandiya 2087*, 2009.
Installation. Courtesy Nadour Collection, Düsseldorf

/ Jack Persekian

a place of blocking. In 1948 Qalandiya became the site of one of the refugee camps that still exist today and are run by UNRWA (United Nations Relief and Works Agency for Palestine Refugees in the Near East).[1] It encapsulates different layers of history in this one very small spot.

So, this very quiet village north of Jerusalem that became an airport, then a refugee camp, and is now a huge checkpoint, where people get stopped and mobility is impeded—this is synthesized in the name.

> CT: How successful was the first Biennial? And what were some of the things you changed for the second one?

JP: What was very successful was the way we structured it, which is completely different from any other biennial in the world. We created a consortium of institutions from several cities that came together as the Foundations of the Biennial. It's a bottom-up structure that began from the institutions' individual programs, which were banded together for a period of time, under one umbrella, one title, within the framework of a biennial. I started working with the different partners—creating this network, connecting the people who otherwise do not come together because of the impossibility of mobility in this country. We agreed on a title, framework, and time frame, bringing together the different programs that each institution had already built into its annual programming cycle, which allowed the exhibitions they held in their home base to be part of this one event.

> CT: Was there an overarching theme?

JP: For the first edition, that is, the exhibition in 2012, there was no theme. It was more like a provisional title: *Let's Work Together*. It was a successful show—the success was that it worked! We didn't have a million dollars for a biennial, but actually, when we added up what all the departments had spent on their programs throughout the period, it came to a million dollars. For the second edition, in 2014, we agreed that we needed to focus on a certain topic, so we chose archives as a common theme and concern, under the title *Archives Lived and Shared*. So people delved into their archives, others commissioned artists to do works on the topic of archives, and so on.

> CT: When you say "archives" do you mean the past, the present, or something else?

JP: The great thing about the event was that each institution decided for itself what to do and how to deal with the topic. Some dealt with their history, or the history of the country. Others chose to look into the future and discuss ways to share the work of these artists, how to digitize the exhibition, how to make it available and accessible. Different institutions had different takes on this.

1. "Following the 1948 Arab-Israeli conflict, UNRWA was established by United Nations General Assembly resolution 302 (IV) of 8 December 1949 to carry out direct relief and works programmes for Palestine refugees. The Agency began operations on 1 May 1950. In the absence of a solution to the Palestine refugee problem, the General Assembly has repeatedly renewed UNRWA's mandate, most recently extending it until 30 June 2017." Http://www.unrwa.org/who-we-are, accessed July 31, 2015.

<u>CT:</u> Would you say that the biennial also posits a form of resistance, or a template for collective action toward ongoing or future crises?

<u>JP:</u> I would subscribe more to the term "collective action" than resistance. I believe the biennial, at least this one, is not about resisting, being against something or somebody; rather, it's a call for action, for people to do things: to think, to produce, to engage, to connect and communicate, to move from one place to another, to attract. It's a form of empowerment rather than resistance.

<u>CT:</u> To host a biennial presents an opportunity to bring art as well as tourism to a city. With the Qalandiya International Biennial there's an impediment both to global tourism and to the mobility of the inhabitants. How do you deal with that?

<u>JP:</u> Rightly so, the way you phrase it: we're in a situation where tourism is still actually quite hard to attract, that is, apart from religious tourism, where people go to the holy places in spite of what happens. So, what we're trying to do is change perceptions. By introducing a kind of young, contemporary image, we hope to gradually replace the one that is disseminated by the media—of conflict, of the war zone. And in time conditions might be conducive for different forms of tourism.

<u>CT:</u> Was the West Bank barrier, the concrete wall built by Israel to cut off access from the West Bank, used as a canvas in either of the two Biennials?

<u>JP:</u> Well, the Biennial does not dictate what the events are or should be. It just facilitates communications—invitations for journalists and advertisements and promotion—and it doesn't get involved in what each individual institution does, where or how it works or what it presents. But no—no one from here did anything on the wall.

<u>CT:</u> When will you do the third edition?

<u>JP:</u> We're planning for October 2016, and we're currently having meetings on a regular basis.

<u>CT:</u> With the success of the last Biennial, did new institutions come forward to join the upcoming one? Or are you still working with the same group?

<u>JP:</u> There are many who now want to be part of the group. That's what we're discussing. The problem is that there's always a Catch 22. If you make it really big and allow everyone to take part, it becomes uncontrollable and a bit scary. But if you keep it limited to the initial group then, in my humble opinion, it deprives others who'd really want to be part of something exciting and promising. Also there are institutions involved in other fields, not just visual arts but in research or music, that would like to be part of the Biennial.

Finally, the discussion is primarily on practical issues, and how to manage, how to organize meetings, how to agree on themes, how to handle PR and so on. We are now 13 sitting around a table, so imagine if we were 50—

/ **Jack Persekian**

how would we do that? Frankly, it's more of a logistical, organizational issue than anything else.

 CT: Let's talk about the Palestinian Museum on the West Bank, which is opening on a site near Birzeit University. As the director you are helping to create the largest museum devoted to the diverse history of the Palestinians, their lands, and the millions who live abroad. I've seen construction photos of the museum, which fits neatly into the desert landscape. How was the architect chosen?

JP: They did an international architectural competition and chose Heneghan Peng, a firm based in Dublin and Berlin. The Welfare Association, a Palestinian philanthropic institution, incubated the idea and has seen it through up to today. Its membership is made up of Palestinian businessmen and businesswomen from different parts of the world.

/ Jack Persekian

Heneghan Peng Architects, Palestinian Museum, Birzeit, 2011. Photoshop rendering. Courtesy Palestinian Museum and Heneghan Peng Architects

The museum's also building a network that allows it to connect through branches and partnerships in and outside of Palestine. Inside Palestine we're thinking, of course, of Gaza. We need to reach out to Gaza, which is completely isolated, almost removed from the context. Then we're also thinking about other places that are home to Palestinian populations: Jerusalem; Haifa; Jordan; Amman; Beirut; Dubai; London; San Diego, California; Santiago, Chile. We have several connections in these different locations, and we want to work out partnership deals with them.

We're now planning the inaugural exhibition for the building in Birzeit, but at the same time we're developing a different show for Beirut, both of which will open in mid-2016. They are not the same exhibition; rather, they are shows that the Birzeit Museum is organizing for different places. For the exhibition in Beirut we hired a curator from London, Rachel Dedman, who has worked on Palestinian and Lebanese issues.

CT: James Scarborough, writing in the Huffington Post about the second Qalandiya International, said, "Sometimes just continuing against all odds to make, exhibit, and look at art is the most defiant thing an artist and his fellow artist citizens can do."[2] Do you think that art has the ability to give agency to a group of people? To change anything?

2. Http://www.huffingtonpost.com/james-scarborough/the-qalandiya-internation_b_5970512.html, accessed Aug. 1, 2015.

JP: It changed me! I don't know what I would have become had I not had the privilege of being exposed to art at an early age. The problem is that here in Palestine, many people, primarily young people, do not get a chance to experience the kind of freedom art brings to people, and the kind of empowerment it provides them, or at least makes available to them. They're limited by tradition, by religion, by poor educational systems, by deprived environments that have really not much to offer, and hence, you get a nation that is in essence lacking the imagination and the opportunity to change things, and that's where I feel we've lost the battle. That's why in areas that are very close to here, you see all these wars, you see all this destruction, because people are hopeless, and hopeless people, desperate people, do desperate things.

CT: Baudrillard wrote: "For something to be meaningful, there has to be a scene, and for there to be a scene, there has to be an illusion, a minimum of the real, with carries you off, seduces, or revolts you. Without this properly aesthetic dimension, mythic or ludic, there is not even a political scene where something can happen."[3] So much of the art that is emanating from Palestine is political. Are there certain artists who transcend the political into the mythic or the ludic?

3. Jean Baudrillard, *Fatal Strategies*, Semiotext(e) Foreign Agents Series (Los Angeles: Semiotexte, 2008), p. 90.

JP: Some artists try to do that, but we're in so many ways doomed by the very heavy political environment that overshadows

/ **Jack Persekian**

everything in our life. No matter how you want to deal with things, it always bumps up against one of these limitations, one of these boundaries. The smarter, more intelligent artists have used that to their advantage by taking the political situation, the conflict, as material to consider in a more global context—trying to compare or reflect on conflicts in other places. This puts the Palestinian cause within a more universal question of human rights, issues related to freedom and the right to self-determination, nationhood.

> CT: The evolution of biennial curatorial practice and the Internet (and social media) have run on parallel tracks over the past 25 years. Both serve as platforms for exposing art to the public. Are there artists in your country who are creating digital art?

JP: Definitely. I've seen it happen exponentially. During the last war in Gaza, there were artists doing some amazing work through Facebook that brought them international attention. For instance, Nidaa Badwan confined herself to one room throughout the war; she produced photographs of herself and posted them on the Internet, and she is now invited to places in Japan and in the States and I don't know where....

> CT: Do you think that the Palestinian Museum and the Qalandiya Biennial can in some way serve as vehicles for statehood?

JP: They do, although statehood is something that is actually being debated now: What does statehood mean, and how to think about statehood in a

/ Jack Persekian

Emily Jacir, *Memorial to 418 Palestinian Villages Which Were Destroyed, Depopulated, and Occupied by Israel in 1948*, 2001. Refugee tent and embroidery thread. Photo: Michael Stravato, courtesy Station Museum of Contemporary Art

place like Palestine, where half of the population lives outside the geograph-
ical boundaries, the historical boundaries of Palestine, in the diaspora?
How do you deal with that, what do you do with that?
The thorniest issue is the right of return. The problem is that when the
Oslo Accords were negotiated, they said, "Well, we can negotiate it to the
1967 border, but you cannot include the right of return for those who are
outside." So it's the 1967 borders only for those who still live within those
borders, but not for those who were dispersed and whatnot. And that is
what's making this a very, very complex issue.
And so, if one thinks about a museum as one of the pillars of the state,
some people will say, "Well, if it's the state that is prescribed according
to the Oslo agreement," which excludes everybody who lives outside of
the '67 borders (and which is only one-fifth of historic Palestine), "then
that's a big problem. Because I don't want to be involved with a museum
that only represents one-fifth of the population." That's why the Palestinian
Museum will have a heart in Birzeit, and branches, wherever possible,
where there are Palestinian communities.

> CT: I understand, but again, I ask: Will this museum help to facilitate
> some form of statehood?

JP: Absolutely! Because it does raise these questions, and it does try to
answer them—not from the limited political lexicon of the politicians who
are here, but from a far broader narrative that is brought about from the
wider network of this museum, throughout the world and wherever there
are Palestinian communities.

/ Jack Persekian

Poklong Anading, *Raining in Spring
(Dwelling Project)*, 2012. Chromogenic
print and LED lightbox. 9th Gwangju
Biennale, 2012. Courtesy the artist and
1335MABINI

Nancy Adajania is an Indian-born independent curator and cultural theorist based in Mumbai. She is currently a research scholar at BAK/Basis voor actuele kunst in Utrecht. Adajania was co-artistic director of the 9th Gwangju Biennale in South Korea (2012). Other curatorial projects include *The Landscapes of Where* at Galerie Mirchandani + Steinruecke in Mumbai (2009), *Avatars of the Object: Sculptural Projections* at The Guild/NCPA in Mumbai (2006), and *Zoom! Art in Contemporary India* at the Culturgest Museum in Lisbon (2004). She has written and lectured extensively on contemporary Indian art, especially new media art and its political and cultural contexts. Her essays have appeared in books and anthologies including *Art and Visual Culture in India: 1857–2007* (2009) and *Tiger by the Tail: Women Artists of India, Transforming Culture* (2007). From 2000 to 2002 she served as editor-in-chief of *Art India*. Adajania studied political science at Princess Alexandra School at Elphinstone College in Mumbai, social communication media at Sophia Polytechnic in Bombay, and film at the Film and Television Institute of India in Pune.

Wassan Al-Khudhairi is of Iraqi origin and serves as the curator of modern and contemporary art at the Birmingham Museum of Art in Alabama. Al-Khudhairi was previously co-artistic director of the 9th Gwangju Biennale in South Korea (2012). She was the founding director of Mathaf: Arab Museum of Modern Art in Qatar. Among the exhibitions Al-Khudhairi has curated are *Sajjil: A Century of Modern Art* and *Cai Guo-Qiang: Saraab*. She has lectured around the world on the subject of modern and contemporary art, specifically related to the Middle East. She holds a M.A. with Distinction in Islamic art and archaeology from the School of Oriental and African Studies at the University of London and a B.A. in art history from Georgia State University. She completed the Museum Leadership Institute program at the Getty Leadership Institute at Claremont Graduate University and, in 2014, participated in the Independent Curators International Curatorial Intensive in New York.

David Elliott is a British-born curator and writer based in Berlin. He is president of the board of Triangle Art Network/Gasworks in London, chairman of MOMENTUM in Berlin, and a visiting professor in curatorship at the Chinese University in Hong Kong. He served as president of CIMAM (the International Committee of ICOM for Museums of Modern and Contemporary Art) from 1998 to 2004, director of MoMA Oxford from 1976 to 1996, and the first director of both the Mori Art Museum in Tokyo (2001–6) and the Istanbul Museum of Modern Art (2007). Elliott was the artistic director of *A Time for Dreams,* the IV International Biennial of Young Art, in Moscow (2014); the director of the inaugural International Biennale of Contemporary Art in Kiev, Ukraine (2012); and the artistic director of the 17th Biennale of Sydney (2010). Other international curatorial projects include *PANDAMONIUM: New Media Art from Shanghai* in Berlin (2014) and the Hors Piste Film Festival in Tokyo. Elliott studied modern history at the University of Durham, and art history at the Courtauld Institute of Art in London.

Mami Kataoka is based in Tokyo, where she has served as chief curator at the Mori Art Museum since 2003. She was co-artistic director of the 9th Gwangju Biennale in South Korea (2012). Kataoka curated *Ai Weiwei: According to What?* at the Hirshhorn Museum and Sculpture Garden in Washington, D.C. (2012) and *Phantoms of Asia: Contemporary Awakens the Past* at the Asian Art Museum in San Francisco (2012). Kataoka was the international curator at the Hayward Gallery in London (2007–9) and chief curator of the Tokyo Opera City Art Gallery (1998–2002). She frequently writes and lectures on contemporary art in Asia. Kataoka received a B.A. from Aichi University of Education.

Sunjung Kim is an independent curator based in Seoul. She is currently a professor at the Korea National University of Arts, the associate director of Artsonje Center, and the artistic director of the Asian Culture Information Agency in the Asian Culture Complex in Gwangju. Kim was co-artistic director of the 9th Gwangju Biennale (2012), the agent of Documenta 13 (2012), and the artistic director of the 6th Seoul International Media Art Biennale—Media City Seoul (2010). She was also appointed as the commissioner of the Korean Pavilion at the 51st Venice Biennale (2005). Other international curatorial endeavors include *Your Bright Future*, an exhibition of 12 contemporary artists from Korea presented at the Los Angeles County Museum of Art and the Houston Museum of Fine Arts (2009–10). In 2005 Kim founded SAMUSO: Space for Contemporary Art, a curatorial office based in Seoul. Through SAMUSO she established Platform Seoul,

an annual art festival whose editions have included *Projected Image* (2010), *Platform in KIMUSA: Void of Memory* (2009), and *I have nothing to say and I am saying it* (2008). Kim received her B.F.A. from Ewha Womans University and her M.F.A. from Cranbrook Academy of Art in Michigan.

Koyo Kouoh was born in Cameroon and works as a curator and cultural producer in Dakar, Senegal. Kouoh is the founding artistic director of RAW Material Company, a center for art, knowledge, and society established in Dakar in 2008. She is a curator of FORUM, the education program at 1:54 Contemporary African Art Fair. The EU Delegation in Senegal and the Senegalese Ministry of Culture entrusted Kouoh with the development of a reform for the 11th Dak'Art: African Contemporary Art Biennial (2014). She served as curatorial advisor to Carolyn Christov-Bakargiev for Documenta 13 (2012) and curatorial advisor to Okwui Enwezor for Documenta 12 (2007). She collaborated on the 4th, 5th, and 6th Dak'Art (2000, 2002, and 2004) and co-curated the 4th and 5th Bamako Encounters: African Biennial of Photography (2001, 2003). Kouoh was a member of the Golden Lion Jury at the 50th Venice Biennale in 2003. Her recent writing projects include *Word!Word?Word! Issa Samb and the undecipherable form* (2013) and *Condition Report on Building Art Institutions in Africa*, a collection of essays resulting from the eponymous symposium held in Dakar in 2012. She was educated in banking administration, cultural management, and curatorial practice in Switzerland, France, and the U.S.

Carol Yinghua Lu was born in Guangdong, China, and currently lives and works in Beijing. She is the artistic director and chief curator of OCAT Shenzhen, a contributing editor for *Frieze*, and sits on the advisory board of The Exhibitionist. Lu was one of the six co-artistic directors of the 9th Gwangju Biennale (2012), and she co-curated the 7th Shenzhen Sculpture Biennale (2012). She was on the jury for the Golden Lion Award for the 54th Venice Biennale (2011). Lu was the first visiting fellow of the Tate Research Centre for art of the Asia-Pacific (2013), and was the founding Art Director of SUITCASE ART PROJECTS, a project space of Today Art Museum (2009–10). She has co-authored several publications with Liu Ding, including *Individual Experience: Conversations and Narratives of Contemporary Art Practice in China from 1989 to 2000* (2013), *Little Movements II: Self-practice in Contemporary Art* (2013), and *Little Movements: Self-practice in Contemporary Art* (2011). In 2005 she graduated from the critical studies program of Malmö Art Academy at Lund University, Sweden.

Gerardo Mosquera was born in Cuba and now works as a curator, critic, and art historian in Havana. He served as advisor for visual arts and design to the Ministry of Culture in Havana in 1980–85. During his directorship of the research department at the Centro Wifredo Lam in Havana, he co-founded the Havana Biennial and was integral to its curatorial team on the 1984, 1986, and 1989 editions. Since then he has curated a range of international biennials and exhibitions, including *Border Jam* in Montevideo (2007); *Transpacific* in Santiago (2007); and *Panorama of Brazilian Art* in São Paulo, Rio de Janeiro, Recife, and Vigo (2003). Collaborative exhibitions include the Liverpool Biennial International (with Manray Hsu) (2006); *Cordially Invited* (with Maria Hlavajova), Utrecht (2004); *MultipleCity* (with Adrienne Samos), Panama (2003); *Cildo Meireles* (with Dan Cameron), New York (1999). Mosquera was chief curator of the *Poly/ Graphic Triennial* in San Juan (2015) and artistic director of *PHotoEspaña* in Madrid (2011–13). He was adjunct curator at the New Museum of Contemporary Art in New York from 1995 to 2009. Mosquera's writings on contemporary art and art theory have been widely published in journals and books.

Ugochukwu-Smooth Nzewi was born in Nigeria and is based in the United States. In 2013 he became the inaugural curator of African art at the Hood Museum at Dartmouth College. Nzewi co-curated the 11th Dak'Art: African Contemporary Art Biennial in Senegal (2014). He has curated exhibitions in Nigeria, South Africa, Senegal, and the U.S., including *Transitions: Contemporary South African Works on Paper* at the High Museum of Art in Atlanta (2009) and *Windows Part 1: New Works by Ndary Lo* as part of the fringe exhibitions of Dak'Art 2012. Nzewi received his Ph.D. in art history from Emory University, where he wrote his doctoral dissertation on the Dak'Art Biennial and its influence on contemporary African art from 1992 to the present. He was awarded a pre-doctoral fellowship from the National Museum of African Arts, Smithsonian Institution, in 2012, and earned a postgraduate diploma in the African Program in Museum and Heritage Studies from the University of Western Cape, South Africa. Nzewi studied sculpture with El Anatsui at the University of Nigeria, Nsukka, where he earned a B.A. in fine and applied art. As an artist he has participated in more than 30 exhibitions and artist residency programs in Africa, Europe, and the U.S.

Jack Persekian was raised in Israel and currently lives and works as a curator and producer in Jerusalem and Birzeit. He is the founding director and head curator of the newly opened Palestinian Museum. Persekian was the artistic director of the 1st and 2nd Qalandiya International Biennials

(2012, 2014). He founded and directed the Anadiel Gallery, the Al-Ma'mal Foundation for Contemporary Arts in Jerusalem, and XEIN Projections. Exhibitions he has curated include *DisOrientation II: The Rise and Fall of Arab Cities* at Abu Dhabi Art (2009), *The Jerusalem Show* in Jerusalem (2007, 2009), *Reconsidering Palestinian Art* in Cuenca, Spain (2006), *Disorientation: Contemporary Arab Artists from the Middle East* at Haus der Kulturen der Welt, Berlin (2003), *In weiter ferne, so nah, neue palastinensische kunst* at Ifa Galleries in Bonn, Stuttgart, and Berlin (2002), and the Official Palestinian Representation to the 24th São Paulo Biennial (1998). He was artistic director of the 8th and 9th Sharjah Biennials (2007, 2009) and chief curator of the 7th Sharjah Biennial (2005). Persekian has also directed and produced the Palestinian Cultural Evening at the World Economic Forum in the Dead Sea, Jordan (2004), and the Millennium Celebrations in Bethlehem (2000).

José Roca is a Colombian curator living and working in Bogotá. He is artistic director of FLORA ars+natura, an independent space for contemporary art in Bogotá. He served as the Estrellita B. Brodsky Adjunct Curator of Latin American Art at Tate, London, from 2012 to 2015. Roca was the chief curator of the 8th Mercosul Biennial in Porto Alegre, Brazil (2011). From 2006 to 2010 he was the artistic director of Philagrafika, Philadelphia's International Triennial celebrating print in contemporary art. He co-curated the Encuentro de Medellín MDE07 (2007), the 27th São Paulo Biennial (2006), and the 1st San Juan Poly/graphic Triennial in Puerto Rico (2004). He also served on the awards jury for the 52nd Venice Biennial (2007). From 1994 to 2008 Roca managed the arts program at Banco de la República in Bogotá. With Sylvia Suarez he co-wrote *Transpolitical: Art in Colombia 1992–2012*. Roca studied architecture at the Universidad Nacional de Colombia, specialized in critical studies in the Whitney Independent Study Program in New York, and holds a masters degree in the design and administration of cultural buildings from the École d'Architecture Paris-Villemin.

Bisi Silva was born in Lagos, Nigeria, and works as an independent curator based in Lagos and London. She was artistic director of the 10th Bamako Encounters: African Biennial of Photography (2015), co-curator of the 2nd Thessaloniki Biennale of Contemporary Art (2009), and co-curator of the 7th Dak'Art: African Contemporary Art Biennial (2006). Silva is founding director of the Centre for Contemporary Art in Lagos (CCA, Lagos). She co-curated *The Progress of Love*, a transcontinental collaboration between the Menil Collection (Houston), Pulitzer Foundation for the Arts (St. Louis), and CCA, Lagos (2012–13), and *J. D. 'Okhai*

Ojeikere: Moments of Beauty at the Kiasma Museum of Contemporary Art, Helsinki (2011). A frequent participant in international conferences and symposia, Silva has published in numerous international journals and magazines. She sits on the editorial/advisory boards of *Art South Africa*, *n.paradoxa: international feminist art journal*, and *Contemporary And*. She was a member of the international jury for the Pinchuk Art Centre's Future Generation Art Prize (2014) and for the 55th Venice Biennale (2013).

Alia Swastika was born in Yogyakarta and is now based in Jakarta. She was co-artistic director of the 9th Gwangju Biennale (2012). She presented Indonesian artists as part of the Marker program at Art Dubai 2012, which focused particularly on Indonesia. Previously she curated the 11th Jogja Biennial with Indian curator Suman Gopinath (2011). Swastika began her curatorial career by working as an artistic manager in Cemeti Art House in Yogyakarta and later developed Ark Galerie in Jakarta. She received fellowships from The National Art Gallery in Singapore (2010), the Asian Cultural Council (2006), and the Asia-Europe Foundation in Berlin (2005). Recent independent curatorial projects include *Manifesto: The New Aesthetic of Seven Indonesian Artists* at the Institute of Contemporary Arts, Singapore (2010), and *The Past the Forgotten Time* in Amsterdam, Jakarta, Semarang, Shanghai, and Singapore (2007–8).

Carolee Thea is the author of *On Curating: Interviews with Ten International Curators* (2009) and *Foci: Interviews with Ten International Curators* (2001), which feature conversations with some of the most important artists and curators in the world, including Carolyn Christov-Bakargiev, Okwui Enwezor, Massimiliano Gioni, Hou Hanru, Hans Ulrich Obrist, Rirkrit Tiravanija, and Harald Szeemann. An independent scholar, writer, artist, and curator, Thea has been a contributing editor at *Sculpture* magazine since 1996, and has written for *ArtAsiaPacific*, the *Brooklyn Rail*, *Parkett*, *Modern Painters*, artnet.com, artforum.com, TRANS>arts.cultures. media, and *AShijue 21 Beijing*. She is the American/English editor for *Atlantica #45*. Her published articles and interviews have featured artists such as Joan Jonas, Ai Weiwei, Robert Irwin, Pedro Reyes, Ann Hamilton, Erwin Wurm, Atsuko Tanaka, William Kentridge, Din Q Le, and Mark Bradford. Having written on the cultural rebuilding of Berlin and the first Berlin Biennial, Thea was invited to preview the newly constructed Guggenheim Museum in Bilbao in 1997 and Daniel Libeskind's Jewish Museum, Berlin, in 2000. She has curated exhibitions for the American Institute of Architects, the Canal Street Billboard Project, Hofstra Museum, and Skidmore College, and is a moderator and discussant on panels pertaining to art, culture, and curatorial practice. In 2004 she was

invited as a distinguished visiting scholar at the American Academy in
Rome. She has taught at Pratt Institute, Parsons School of Art, the College
of New Rochelle, and other institutions. She attended Skidmore College
and Columbia University, and in 1976 earned an M.A. from Hunter
College, City University of New York, where she studied art history with
Leo Steinberg and African art with Douglas Fraser. She was awarded
an Artspire sponsorship in 2012, was interviewed in *BOMB* magazine
in 2010, and received an NEA grant in 1990. Thea lives and works in
New York City.

WHW (What, How & For Whom) is a curatorial collective formed in
1999 and based in Zagreb, Croatia. Its members are Ivet Ćurlin, Ana
Dević, Nataša Ilić, Dejan Kršić, and Sabina Sabolović. WHW organizes
a range of production, exhibition, and publishing projects and since 2003
has directed the city-owned Gallery Nova in Zagreb. What?, How?, and
For whom? are the three basic questions that are proposed of every eco-
nomic organization, and are fundamental to the planning, conception, and
realization of exhibitions, the production and distribution of artworks, and
the artist's position in the labor market. These questions formed the title of
WHW's first project, in 2000 in Zagreb, dedicated to the 150th anniversary
of the Communist Manifesto, and became the motto of WHW's work and
the name of their collective. They curated the 11th Istanbul Biennial (2009).
Other exhibitions include *Final Exhibition* at Galerija Nova in Zagreb
(2006), *Collective Creativity* at Kunsthalle Fridericianum in Kassel (2005),
Normalization at Gallery Nova in Zagreb (2004), *Side-effects* at the Museum
of Contemporary Art in Belgrade (2004), *Looking Awry* at Apexart in New
York (2003), and *Broadcasting Project*, dedicated to Nikola Tesla, at the
Technical Museum in Zagreb (2002).

Acknowledgments

I would like to express my thanks to all the interviewees for their willingness to discuss their methods and motivations; to NYFA (Artspire) for the fiscal support; and to the biennial foundations that funded my research and travel. I also thank the artists, photographers, galleries, and institutions that provided illustrations for this publication. Special thanks to Sharon Helgason Gallagher, president and publisher of D.A.P., for her enthusiasm in making this book possible. I am grateful as well to Thomas Micchelli, Diana Murphy, Jordan Steingard, Bethany Johns, Christopher Phillips, Carolyn Christov-Bakargiev, Mark Spellman, and to my assistants, Melissa Gollance and Brian Bentley. Thanks to my family, Doug, Ruthie, Jane, Tom, Erica, Josh, Zack, Karli, and Chaz.

I dedicate this book to the memory of my longtime friend and mentor Leo Steinberg. —C.T.